The Shining

Scene-by-Scene

The Shining
Scene-by-Scene

John David Ebert

© 2015 John David Ebert
All rights reserved

ISBN: 1515105490

Acknowledgements

Special thanks go to Michael Aaron Kamins, as usual, for reading the manuscript; Lawrence Pearce, for his wonderful cover art; and Tom Ebert for his cover design.

Contents

A Few Words Before the Play: On Difference & Repetition in *The Shining* 11

Opening Credits:
The Ascent up the Mountain 21
The Interview 27
The Episode in Boulder 33
Ascent Redux 39
The First Sighting 43
The Tour 49
The Conversation 55
Waking Up 59
The Hedge Maze 63
The Interruption 67
Ruptured Lines 71
Father and Son 77
Jack's Nightmare 81
Jack's First Conversation with Lloyd 87
Room 237 91
Jack's Report 97
Charles Delbert Grady 103
Hallorann on His Way 109
Confrontation 115

Trapped	121
Redrum	125
Hallorann's Arrival	129
Navigating the Labyrinths Part I	133
Navigating the Labyrinths Part II	137
Frozen in Space; Frozen in Time	143
Endnotes	147
Bibliography	157

A Few Words Before the Play:
On Difference & Repetition in *The Shining*

Stanley Kubrick's 1980 film *The Shining* is about the "polymorphia" of seriality and repetition. What it is *not* about is the production of the new, or the singularity that ruptures a previously metastable system and transforms it into something completely novel. The Overlook Hotel is a place where the presence of the past weighs so heavily on the *now*, that *new* events simply cannot get out from under the weight of past ones.

However, the child with the ability to foresee future events before they happen—and to communicate telepathically across vast distances--*is* a singularity which the mind of the hotel does not understand and so it wants Danny for itself, to incorporate his particular abilities within the resonant echo chamber of its astral architecture. In order to do this, it requires the wearing of the child's father as a sort of tribal mask—a Native American Wendigo, let's say—to kill the child so that it can then absorb his astral and etheric energies, thus making the hotel stronger than ever. Then the boy can remain a boy and "play" inside the hotel for all eternity.

Everywhere one looks in *The Shining*, one finds repetitions and seriality: things, people and events always come at least in pairs, sometimes in triples, and often multiples. The doubling effect, for instance, is part of the film's obsession with mirrors: Danny, when we see him talking to Tony in the bathroom in the Boulder apartment is looking at his own image in the mirror (his physical double), while Tony is his psychological double, the entity that confers upon him the power to foresee future events and also events that are in process of happening at the present moment. (For instance, he tells Danny in this scene that Jack is just about to phone Wendy to inform her that he has gotten the job as caretaker of the Overlook Hotel for the winter). When Jack later enters Room 237, the double of the woman that he is kissing is reflected back at him in the mirror in asymmetric fashion as a decaying corpse. When, early on in the film, he wakes up and Wendy is serving him breakfast, while looking at himself in the mirror, he sticks his tongue out, thus prefiguring his later devolution into the entity which I have termed "*Not*-Jack" when he is menacing Wendy at the top of the stairs and insisting that she put the baseball bat aside and flicks his tongue out at her multiple times like a snake.

There is also a series of bathrooms in the film: the one in the apartment in Boulder where Danny has his first vision, the one in Room 237, the one in which Delbert Grady informs Jack that he had better do something about his son's attempt to bring in an outside party to the hotel, and the one in which Wendy is nearly killed by Jack. Of course, all these bathrooms have mirrors and something supernatural occurs in every one of them, but there are more mirrors than bathrooms in the film, since in addition to the mirrors in those particular bathrooms, there is also the mirror behind Lloyd the bartender that recalls Monet's famous

1882 painting *Bar at the Folies-Bergere*, and the mirror in the apartment of the Torrance's bedroom. In *Through the Looking Glass*, Lewis Carroll's sequel to *Alice in Wonderland*, the mirror above the mantel through which Alice disappears into an alternate reality reflects things back at her in strangely distorted forms that carry their own kind of sense, although they may be paradoxical at the same time. Sense, as Gilles Deleuze points out in his book *The Logic of Sense*, need not necessarily coincide with "truth" vs. "falsehood," since a thing can be both paradoxical and yet make sense without being either "true" or "false."[1]

Consistent with the film's fascination with mirrors is the film's series of doubles: there are the Grady girls (who are played by identical twins, yet Stuart Ullman tells us that they were 8 and 10 years old when they were killed and are thus asymmetric); there are two Jacks, one from 1921 and the one in the present timeline; and there is Jack's attempt (ultimately foiled) to "double" Grady's murder of his family; there is also the double of the hedge maze as a scale model inside the hotel's reception area, etc. etc.

Events, too, even very small ones, almost always have their echoes: recall how Wendy has trouble opening the lock to the dry goods larder when she is dragging Jack to imprison him in it, and then later, after Hallorann has arrived and distracted Jack's attention from Wendy to go and kill him, she has trouble (once again) with the lock on the bathroom door; or when she is fending off Jack at the top of the stairs in the Colorado Lounge and he reaches out for the bat, she raps him with it on the knuckles, and then when he is later chopping down the bathroom door with the axe and reaches in to unlock it, she again cuts him on the knuckles, this time with a knife, but it is his *left* hand. Jack has *two* conversations with Lloyd the bartender, and *two*

conversations with Charles Delbert Grady, although both recurrences are under slightly different circumstances (and three of the four occurrences take place in front of mirrors). Even the yellow VW's drive up the mountain to the hotel occurs *twice*, once during the film's opening credits when Jack is by himself, and then again after he has gotten the job as winter caretaker and goes back up with Wendy and Danny.

Things and objects in the film also occur in multiples: there is the one sentence typed by Jack on his typewriter over and over again which, when discovered by Wendy, is scored with Penderecki's (pronounced "Pen-der-etz-gee") composition entitled *Polymorphia*, by which Penderecki meant "the same sound in many forms," which weirdly echoes her discovery of the same sentence in many forms. The hedge maze is itself a recursive reiteration of multiple right angles, and in the dry goods storage room, the shelves are stocked with multiple boxes of Tang and serial rows of cans of Calumet baking powder, like an Andy Warhol soup can or a Coke bottle painting. (The series of 21 black and white photographs on the wall across from the Gold Room in the film's final scene seems to belong to this category, as well).

The point is that everything in the Overlook Hotel is repeated: events, people, things, objects, however small or innocuous. There *are no singularities whatsoever at the Overlook Hotel,* although the hotel itself is a spatio-temporal singularity, a sort of reverse event horizon like a temporal black hole down into which events are sucked and stored in the form of subtle energy. The hotel is located at the top of the Rocky Mountains in a zone of Temporal Absence, and where time, such as it occurs at all, runs round in circles like the events of the mythical consciousness structure of

the pre-metaphysical age of the ancients before writing and criticism came along to cut the repetition of the eternal circles out and lay them flat into stacks of written lines on papyrus and parchment during the time of Plato and the Hebrew prophets.[2] As Eric Havelock pointed out in his *Preface to Plato*, the real reason that Plato didn't want poets in his academy was precisely because they repeated things by singing them through rote memorization that did not allow novelty to occur.[3] With the Greek metaphysical age invention of the philosopher, each thinker is himself a singularity, not someone who passes on received wisdom in the form of proverbs, but someone who extracts singular Ideas from the flow of human banalities and cliches.

The exception to all this, of course, is Danny, who has the power to foresee the future and to make telepathic long distance distress calls to people like Hallorann, who comes running from Florida in order precisely to stop the repetition of an event from *re*-happening: the Grady murders, which Jack is about to duplicate and which he is stopped from doing by Hallorann's arrival. Though Jack kills him, Hallorann's snowcat provides Wendy and Danny with a means of escape down the mountain that cuts the circle of eternal return and breaks it open, perhaps for the first time in the hotel's history.

In Gilles Deleuze's book *Difference and Repetition*, he describes three different kinds of syntheses of time: there is the synthesis of habit, in which the past simply contracts into the present; there is the synthesis of memory, in which an I – Self axis is formed between the present-past and present-present; and finally, there is the synthesis of what Deleuze calls "empty time" in which the Eternal Return brings something back completely transformed in such a way as to rupture all previous sequences and introduce

something new. A difference, in other words, rather than a mere repetition.[4]

Alain Badiou's "event ontology" in his book *Being and Event* was inspired by Deleuze, but for Badiou, the event-as-singularity creates a new Subject precisely through that subject's fidelity to one or another truth event: the Haydn classical music truth event, let's say, or the truth event of Einsteinian physics. The truth event, for Badiou, introduces a singularity into the previous status quo of a situation and "fills" the empty set—Badiou draws from set theory—with what had been missing from the previous situation. The event, for Badiou, thus creates a new truth that "subjectivizes," whereas for Deleuze the third synthesis of time, empty time, simply blows subjectivity to pieces and creates "the man without qualities," an individual who has been cut away from all connecting vectors and lines of force and given a completely new identity that never existed before.[5]

In *The Shining*, Danny is the human singularity who enters into the Overlook Hotel's field of morphic repetitions, and blows the system apart by preventing the Eternal Recurrence of yet another one of its murders simply by sending out a telepathic distress signal to Hallorann that causes him to trace a line of flight that brings him back to the system so that he can rupture it and prevent the circle from closing in on itself.

The Overlook Hotel, as the circular shape of the first letter of its name suggests, is a place where the ancient mythic Uroboros of the serpent biting its tail predominates. Things there run round in circles, although the repetitions and circles may occur with *slight* differences—for example, when Jack confronts the bartender Lloyd a second time, the Gold Room is full of people, whereas it had been empty during their first encounter; or the asymmetry of the word

"Redrum" that is reflected back in the bedroom mirror as "Murder"; or Wendy and Danny's first casual stroll through the hedge maze which is repeated at the end of the film as Danny's run through the maze in terror; and not every sentence of Jack's manuscript is typed in *exactly* the same way, for there are many typos, spelling errors, etc. The repetitions and doublings, then, are not *quite* the same. They recur and recur eternally, but always with a difference in the repetition that makes each occurrence a *little* different. Yet not different enough to allow for the creation of a true singularity, for the hotel will not tolerate unprecedented events. It lives off its memories of the past, like an old man stuck in his nostalgic reminiscences.

Which explains why it wants Danny, a true human singularity—just as the hotel is a spatio-temporal architectural singularity--all to itself, because the hotel fears that he possesses the possibility to break circles, rupture repetitions and create new sequences of events. (In Badiou's set theory, this would be tantamount to creating new sets in infinite chains of signifiers, each set blooming out of the "zero point" that formed the null of each previous set).[6]

Thus, whereas the film began with the Torrance family's ascent up the mountain in a VW bug, it ends with their descent down the same mountain road, covered with snow this time, and without Jack, leaving Wendy and Danny travelling alone in the snowcat. Even the broken circle has its asymmetric mirror image at the film's beginning and ending scenes.

But by the film's conclusion, the circle of repetition has finally been broken.

The Overlook's mirror(s) is (are) shattered.

And it has had to settle for losing Danny and reacquiring Jack Torrance a second time.

But now let's take a detailed scene-by-scene look at how that process of the rupturing of repetition with a true difference in *The Shining* comes to take place.

"Easy is the descent to Avernus, for the door to the underworld stands open both day and night. But to retrace your steps and return to the cool air above: *that's* the task, *that's* the toil."
--Vergil, *The Aeneid* Book VI.126-129

"The way up and the way down are one and the same."
--Heraclitus, Fragment 60

Opening Credits:
The Ascent up the Mountain
(0:00 – 2:59)

The first shot of the film is taken from the perspective of a helicopter doing a quick fly-by over a mountain lake where a small island densely packed with trees in yellow and orange autumn foliage juts up above the smooth glassy surface like the visible half of some ancient wrecked ship. (In reality, it is St. Mary Lake located in Glacier National Park at the northern edge of the Rockies in Montana. The island in the center of the lake is known as Wild Goose Island).[7]

The next shot then hovers high in the air above, like a disembodied spirit, looking directly down at a tiny yellow VW Volkswagen making its way across a curving road that winds along through a forest of pine trees. In the subsequent shot, the Volkswagen is seen travelling along almost at ground level, while in the glossy white distance, the cool, icy bergs of the Rocky Mountains loom as the VW's destination point. As the blue letters of the film's title credits begin to roll up from below, each subsequent shot follows the progression of the car as it ascends ever higher and higher into the Rockies in the speckled gold sunlight of late autumn.

As it climbs into the mountains, the aerial point of view follows the tiny car as it rounds precarious curves and goes through tunnels into the mountainside, while vast, deep chasms and vistas of giant green valleys open up all around it. The viewer has the sense of floating, as though he or she were a discarnate spirit soaring up into the cold realm of chiseled limestone and black basalt peaks along the blue-gray mountainsides. As the tiny car ascends higher, the sides of the mountain become covered with a light sift of powdery snow, and the viewer soon realizes that he has at last ascended to the top of the mountain where a bulky gray hotel with peaked, pyramidal roofs is perched amongst a few scattered green pines. Behind it, there looms a mountain peak covered in a thin skin of cream-colored snow. (In reality, the shot is an exterior view of the Timberline Lodge located on Mount Hood in Oregon).

The VW has finally reached its destination and can be made out to the discerning eye as one of the cars parked amongst the twenty-five or thirty others in the Overlook Hotel's parking lot.

The first point to note is the film's vector of ascent: from below *upwards*. The viewer is travelling along with the story's protagonist Jack Torrance to an elevated plane—the realm of Spirit, as James Hillman would put it in terms of his opposition of "peaks and vales"[8]—a plane of consciousness that is far removed from the ordinary everyday world of the banal and the mundane. Indeed, the immediate *literary* point of comparison is to the opening chapter of Thomas Mann's 1924 novel, *The Magic Mountain*, in which the novel's young protagonist, a nautical engineer named Hans Castorp, is ascending by train up into the Swiss alps near Davos to the Berghof Sanitarium—an actual sanitarium that was built there around 1900 as a place of rest and relaxation

for tubercular patients, but was bought and reterritorialized as a hotel in 1954 and also renamed the Hotel Schatzalp. Mann points out interesting details such as the change in scenery as Castorp ascends, noting that the landscape shifts from deciduous trees which die in the winter and grow leaves again in the spring, to the evergreens of higher altitudes, such as the pines, firs and oaks that stay green all year long and therefore connote the realm of *eternal* values. The Overlook Hotel and the Berghof Sanitarium have more than a little in common,[9] for each occupies a realm "above" where consciousness is "different" than the slower-moving temporalities of the flatland down below, a land which Mann equates with the realm of social duties and responsibilities. The elevated realm at the top of the mountain is a place where magical transformations occur, and this is also evident in works of art like Hans Thoma's 1899 painting *Die Gralsburg*, (shown below) which depicts a trail of knights riding horses along a path that leads to the distant peaks of a mountain carved in the shape of a castle (specifically, the Grail Castle). The knights, too, are moving from the flatland of daily concerns—the Biotemporal World, we might say-- to ascend into the realm of myth, magic and spirit where contact with supernatural powers is a "normal" occurrence.

Jack Torrance, an alcoholic writer who has recently moved from Vermont to Boulder, without knowing it, then, is ascending into a realm of Axial Intersection where the plane of the living intersects with, and crosses over into, the astral realm of the dead, a zone where time ceases to function in a linear manner.

The music which Stanley Kubrick has chosen as the soundtrack for this sequence of ascent to the spirit world highlights and underscores its imagery, for it is an electronic adaptation by Wendy Carlos and Rachel Elkind of just a few

notes from Hector Berlioz's 1830 *Symphonie Fantastique*.[10] Specifically, the notes are taken from the fifth and last movement of that symphony, which is entitled "Dream of the Night of the Sabbath," and refers specifically to the Witches' Sabbath which Goethe in his epic of *Faust Part I* (published in 1808) terms the "Walpurgis Night,"[11] and which is set in the Hartz mountains where ghosts and spirits gather for a festival. The title of Thomas Mann's novel *The Magic Mountain* specifically refers to this scene, for in it, a fleeting spirit tells Faust, "The mountain is mad with magic tonight!"

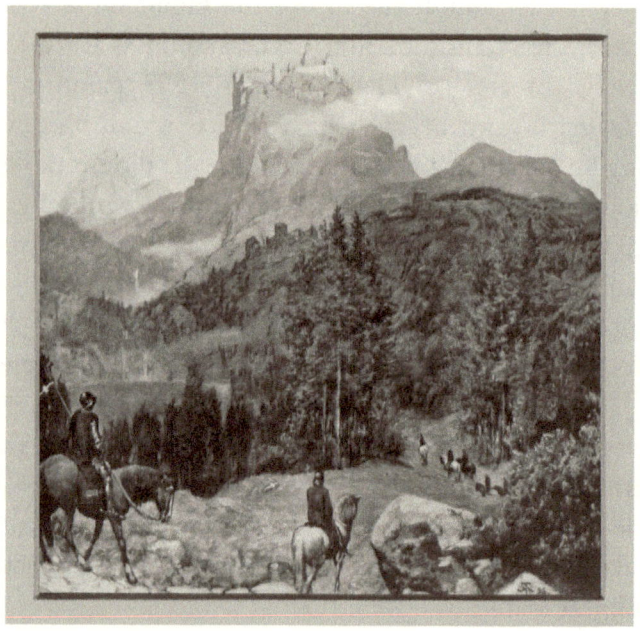

Kubrick's allusion to Berlioz's *Symphonie Fantastique* is an interesting one,[12] for in it, Berlioz imagines the tale of an artist who has a vision of an ideal woman that he keeps pursuing and failing to find (Jack Torrance, likewise, will catch only a fleeting glimpse of *his* ideal woman when she steps out of the bathtub in Room 237). Feeling spurned by her, the artist attempts to kill himself with an opium overdose, but instead it induces in him a trance vision of seeing himself murder his beloved and go to the scaffold to be hanged for it. Then, in the Fifth and last movement of the symphony, the so-called "Dream of the Night of the Sabbath," he envisions his funeral taking place during a Walpurgis Night where ghosts, spirits, witches and sorcerers of all kinds have gathered, and where his beloved finally turns up, meeting him only in death.[13]

Berlioz clearly had Goethe's *Faust* in mind—who, in turn, may have had Goya's 1798 painting entitled *Witches' Sabbath* in *his* mind (shown below)—but Kubrick's allusion to the symphony not only looks back at this tradition of ascent to an elevated place in the mountains where spirits gather, but is also a foreshadowing of the climax of his own film, *The Shining*, which eventually ends with its *own* kind of *Walpurgisnacht* (although that ceremony is traditionally held in the springtime to drive the evil spirits away, whereas Kubrick's ceremony takes place shortly after the winter solstice, when the sun has gone *down* into the Underworld) wherein a festival of spooks and ghosts gathers inside the Overlook Hotel for an *eternal* celebration.

And whereas Nietzsche, at the beginning of his opus *Thus Spake Zarathustra*, began with his protagonist ascending up into a mountain at the age of 30 to live there for ten years and then descending, with his eagle and his serpent, at the age of 40 to announce to the world that he had discovered

the ultimate "truth" that God is dead and must be replaced with the *Ubermensch*, in Kubrick's narrative the story of Jack Torrance will be an *ascent* to the top of a mountain where spirits gather every winter in order to celebrate the realm of the dead as a vast, eternal and unending party, and he will therefore discover not that "God is dead" but that "spirits are very much alive and well" in the age of cosmopolitan techno-humanity. Nietzsche, as the contemporary Italian philosopher Gianni Vattimo points out,[14] was in reality announcing the *end* of the metaphysical age that had its dim and distant origins in the time of the Greeks, but Jack Torrance, on the other hand, will rediscover and experience the *pre*-metaphysical age of spirits, ghosts and hauntings that are part of what Jean Gebser termed the ancient, and *very* archaic "magical consciousness structure" that still sleeps latently within each one of us.[15]

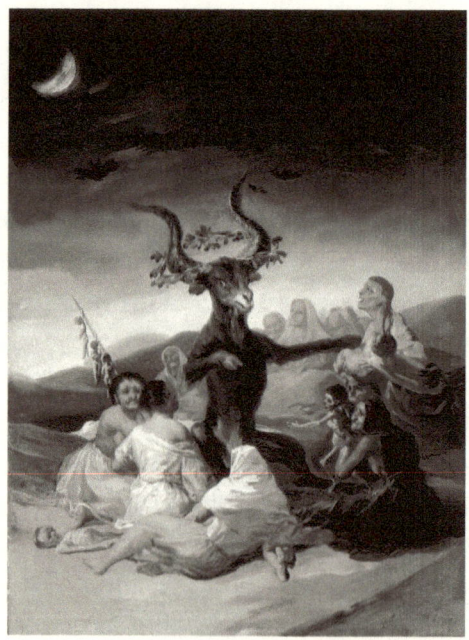

The Interview
(3:00 – 10:32)

The next sequence begins with a title card, "The Interview," which lasts—and is interrupted by one brief scene-within-a-scene—for about seven and a half minutes. It begins with Jack striding confidently into the Overlook Hotel's main lobby, where he heads for the reception desk and asks where he can find the office of one Mr. Stuart Ullman. He is told the office is the first door on the *left*, so the camera follows him taking a left into a small fluorescent-lit foyer where he pauses a moment at the threshold of Mr. Ullman's pink-colored office. (The movie's color palette varies from light pink to dark blood-red). Jack's left turn may seem innocuous, but it is the film's first hint of the dark path which Jack Torrance will follow, since in all the ancient esoteric and religious traditions, the left hand path is always the "sinister" path, the path that leads into the depths of the unconscious and its uncertain murky labyrinthine mazes.

The lavish and beautiful décor of the Overlook's interior has been modeled by Kubrick on a real hotel, the Ahwahnee Hotel located in Yosemite National Park, California. The designs are inspired from Native American cultural motifs,

which is significant, since later on Mr. Ullman will inform Jack that the hotel was built over a Native American burial ground. The film is composed of what Deleuze & Guattari call in their book *A Thousand Plateaus* a "mixed sign regime," and one of those regimes is most specifically Native American.[16]

Kubrick's hotel, however, is a set, both exterior and interior, that was built—the largest ever at the time—in England's Elstree film Studios (since Kubrick had a fear of flying, all shots done in America were composed as second unit shots under the supervision of Jan Harlan). Both *The Empire Strikes Back* and *Raiders of the Lost Ark* were filmed at the same studio, and came and went while Kubrick lingered on *The Shining* for an entire year, 1978-79.

Mr. Ullman, the hotel's General Manager, invites Jack into his office where he briefly introduces him to his secretary and invites him to take a seat. There are two chairs in front of Ullman's desk, and Jack sits in the one on the right—the driver's side in a British automobile, the passenger side in an American one—and Jack informs Mr. Ullman that his drive from Boulder up the mountain to the hotel has taken him about three and a half hours. This highlights the fact that the hotel is in a *very* remote location, nestled at the peak of some lost berg in the midst of the Rockies.

The scene is briefly interrupted at about 4:10, in which Kubrick returns us down to the "flatland"--as Thomas Mann would term it--at the base of the so-called Flatirons in Boulder, where a shabby apartment complex is located. Stephen King wrote the novel while living in Boulder in 1974, where he rented an office in the downtown area with a view looking out at the Flatirons, a series of five peaks made out of 300 million year old sandstone. (That puts them geologically at about the time of the first fish transforming

into amphibians and coming out of the salt water to lay their eggs on land, where they would be safe from other water-dwelling predators).

King and his wife Tabitha had just moved from Maine to Boulder after the death of King's mother in 1974, and one day they drove up to the prophetically named Stanley Hotel, a Colonial Revival built in 1909, where they were the only guests, as the hotel was officially closing down for the winter season the very next day. The Stanley Hotel is located in Estes Park in the Rockies, but it is only about a one hour drive from Boulder.[17]

The emptiness and seclusion of the place creeped King out enough to have a nightmare that night in which his son was running screaming down one of the hallways being chased by a fire-hose. He says he woke up, lit a cigarette and thought the book out right then and there. When they returned to Boulder, he began writing.[18]

He and his wife rented a small house in a neighborhood located right in front of the Flatirons, but in the present scene, Jack's wife Wendy is shown sitting at a lunch table in a Boulder apartment reading *The Catcher in the Rye*, while her son Danny eats his lunch. There are boxes and stacks of unshelved books lying about the dingy apartment, indicating that they have just moved there from Vermont (within about three months). Danny asks his mother if they're really planning on spending the winter up in a hotel and Wendy tells him she is looking forward to it, but when she asks Danny's alter ego, Tony, whether *he* is looking forward to it, Tony tells her bluntly that he isn't. Danny speaks in the voice of Tony using the index finger of his *left* hand, indicating that the voice is coming directly from out of Danny's unconscious.

When the scene returns to Jack's interview in Mr. Ullman's office, they are being joined by Bill Watson, the hotel superintendent, who shakes Jack's hand and sits in the opposite chair. Ullman tells him that Jack will be looking after the hotel for the winter and that he would like Bill to show him around the premises. Mr. Ullman then informs Bill that Jack is a schoolteacher, but Jack corrects him by saying that he has only been doing that to make ends meet and that his real vocation is a writer (Stephen King, incidentally, started out as a high school teacher before selling his first novel, *Carrie*, which enabled him to become financially independent as a full time writer).

Ullman informs Jack that the hotel is open from May 15^{th} to October 30^{th}, and that it then closes down for five months. When Jack asks why they don't stay open for ski season, Ullman tells him that the hotel is simply too remote to keep the roads open and cleared of snow all winter (and therefore is not economically feasible), so they are forced to close it down every year for five months. Ullman tells Jack that his duties would be primarily concerned with monitoring the hotel's boiler and keeping the various areas of the building properly heated and doing repairs as they occur in order that the elements can't get a foothold. (Note that Jack is essentially assigned to identify himself with the hotel's *immune system*).

Ullman tells him that it is not a very physically demanding job, but that there is one other factor that he should consider before taking it on, and that is the tragedy that occurred at the hotel in the winter of 1970 (it is unclear in what year the movie is set as Kubrick deliberately avoids giving specific dates –that is, until the film's final shot—in order to emphasize not only the hotel's remoteness from the striated spaces of cities, but also from the temporal striations of the

calendar governing the flatland down below, for up in the Rockies, the hotel is located in a zone of Temporal Absence). Ullman goes on to say that his predecessor had hired a man named Charles Grady who had impeccable references and brought his wife and two little girls, one eight years old and one ten, to the hotel with him, but that sometime during that winter he killed all three of them with an axe. He chopped them into pieces, which he neatly organized in the hotel's west wing and then put a double-barreled shotgun into his mouth and pulled the trigger. Ullman explains that it must have been an instance of "cabin fever," which he defines as a kind of claustrophobic reaction that can occur when people are shut in together in an isolated situation for too long a period of time.

But Jack reassures Ullman that he is not worried about such things since he will be so busy with his writing, and that it won't bother his wife either, since she loves horror stories. In fact, he tells Ullman that his wife and son will *love* the place.

The scene is morphologically equivalent to "The Mission" scene in *Apocalypse Now*,[19] when Captain Willard is given the assignment by his military superiors to travel up the Nung River and to find and kill Colonel Walter E. Kurtz. Willard, too—take note—had a predecessor, one Colonel Colby, who had been given the same mission a few months prior to Willard's assignment, but he had failed in the mission and gone over to Kurtz's side instead. As I demonstrated in my book about that film, however, Willard carried his mission through and ended up killing Colonel Kurtz, but not on behalf of the military as a hired assassin, but rather as an act of pure freedom of the will after Kurtz puts him through an initiation process that unplugs him from the military order and its Name of the Father and allows him to discover

himself as a free and autonomous individual capable of acts of reasoned, deliberative free will. In doing so, he thereby *breaks* from the mythical circle of Eternal Return; that is to say, of repeating the same archetypal patterns endlessly, and steps *out* of the ring of Urobouros and into the clear light of day in the mental consciousness structure.

The Shining, however, tells the exact opposite story, for Jack Torrance is given the mission not to kill something but rather to become the immune system of the Overlook Hotel for five months. But Ullman, in telling him about the fate of his predecessor Charles Grady, is essentially setting up the precedent of a mythic singularity that is so powerful that it will suck Jack Torrance over its event horizon and slowly take possession of him so that he will end up trying to perform the same act precisely in a *repetition* of the mythical consciousness structure in which all things, as Vilem Flusser put it, run round in circles.[20] Jack will *lose* his autonomy as a human singularity and will gradually become absorbed into the gravitational pull of mythic archetypes that will seize possession of him and flatten him out into a two-dimensional being retrieved out of ancient myth. His fate will end exactly *opposite* to Captain Willard's, for he will lose his sense of acting on behalf of his own free will and interests precisely because he has been assigned to *identify* with the Overlook Hotel and become its immune system, as though it were a living entity. He will thus become trapped and captured by the mythical circle of the serpent biting its tail in the Eternal Return which Joyce calls in *Finnegans Wake* the "seim anew."[21]

The Shining is a story of the devolution and loss of one man's individual consciousness and its regression back into possession by the spirit beings and archetypes of the mythical and magical consciousness structures.

The Episode in Boulder
(10:33 – 17:37)

This next sequence begins with a shot of Danny standing on a footstool in the bathroom of the Boulder apartment as he brushes his teeth and has a conversation with his imaginary friend Tony. As the camera slowly creeps up on him, we hear Tony telling him that his father has just gotten the job to work as caretaker of the Overlook Hotel for the winter and that he will phone his mother up in just a few minutes to inform her of this fact.

There follows a shot of Wendy, dressed in a red shirt with a blue-checked dress (red and blue, incidentally, being the same colors traditionally associated with the Medieval imagery of the Virgin Mary: blue for the sky and red for the spilled blood of her child); she is putting something into the refrigerator when the phone rings and Kubrick shows us Jack in the lobby of the Overlook informing her that he has just gotten the job and will be home later that night.

Then the camera, inside the bathroom now looking over Danny's shoulder at his reflection in the mirror—the first of the film's many mirror (and also bathroom) scenes-- closes in on Danny's image asking Tony why he is afraid of

the Overlook Hotel, but Tony says he doesn't quite know. Danny insists, while talking in Tony's voice with his left index finger, and looking at himself in the mirror, that Tony *does* know why he's afraid and wants him to tell him (the mirror image of Danny reinforces the illusion that there are *two* personalities present here; the motif of doubles will recur throughout the film in many forms: the Grady Twins, Jack and Delbert Grady, the two Jacks, one from 1921 and the one in the present time frame, etc. etc.). But instead of *telling* Danny why he is afraid, he instead shows him a vision of thousands of gallons of blood pouring out of an elevator in one of the alcoves of the Overlook Hotel. It is a sort of Flood myth in miniature, and it completely washes through the alcove in slow motion until the camera lens is covered by it. There is also a brief shot of Grady's two little girls wearing blue-checked dresses (like the one Wendy is wearing in this scene) and of Danny himself screaming (at the moment of Hallorann's murder). Then he blacks out.

When he wakes up, he is being examined in his bedroom by a female doctor. First, she checks one of his eyes carefully, then the other (as though there might be a problem with his vision, but it is actually the unreachable "third eye" that produces visions that is at issue here). The doctor then proceeds to ask Danny whether he remembers anything "funny" while brushing his teeth, like a strange smell or bright flashing lights (such as, for instance, would signal an epileptic attack). He says nothing funny happened but when she asks him if he can remember what he was doing just before he was brushing his teeth, he replies that he was talking to Tony. When she asks whether Tony is one of his animals, Wendy clarifies, cigarette in hand and standing nervously with her back against the bedroom wall, that Tony is Danny's imaginary friend. Danny tells the doctor that

Tony is a little boy who lives inside his mouth and when she asks whether she could see Tony if she looked inside his mouth, he tells her that Tony runs down and hides in his stomach. When she asks whether Tony ever makes him do things, he tells her that he doesn't want to talk about Tony anymore.

There follows a scene in which Wendy and the doctor retire to the living room where, seated on its furniture, Wendy chain smokes as she answers the doctor's questions about when the appearance of Tony, as Danny's imaginary friend, first occurred. She explains to the doctor that Tony's appearance coincided not with the move to Boulder from Vermont, but rather when she and Jack first put him into nursery school, which Danny apparently hated. Then she casually mentions that he had an "injury" at the time, as well, and when the doctor asks for clarification, Wendy, cigarette in hand, explains that Jack came home drunk one night and saw that Danny had scattered his school papers all over the floor and that he had reached out and grabbed Danny to pull him away from the papers and accidentally dislocated his shoulder.[22] Wendy tries to play the violence down by commenting that "it's just the sort of thing you do with a child a thousand times," and adds that Jack subsequently made a vow to stop drinking and told Wendy that if he ever drank again, she could leave him. Jack, she says, has been sober for five months.

The first point to remark upon in this scene is that the way in which Kubrick has chosen to light the bathroom in which Danny is brushing his teeth, with the green shower curtain drawn closed and the green curtains lining the bathroom window while the sunlight is drowned to a soft murky glow, links this scene with the green-painted bathroom that the viewer sees later on in the film in Room

237, in which Danny discovers the corpse of a putrefied and decaying old woman who suddenly comes to life and reaches out and strangles him. (The novel contains a description of this scene, but Kubrick only hints at its occurrence by inserting the image of the decaying woman's corpse coming to life in the bathtub during the scene in which Jack visits the same room). The woman in room 237, as I have stated in a previous chapter, corresponds to the ideal woman which the artist glimpses frustratingly in Berlioz's *Symphonie Fantastique*. The woman in room 237 is Jack's muse, and she strangles Danny for the same reasons that she is strangling Jack's own creativity: she strangles anything he produces. His muse is not the muse that corresponds to what Jean Gebser terms the "soul's life pole," which is associated with water and flowing creativity—hence the bathtub—but rather with what Gebser terms "the soul's death pole," for her *true* image is that of a decayed and life-strangling old hag who cannot be bargained with or charmed away easily.[23]

Wendy is desperately trying to play the role of Jack's muse, but it isn't working and they both know it. Their marriage is already in trouble long before they arrive at the Overlook Hotel which, like a space-time singularity, causes any pre-existing errors, glitches or conditions in the human psyche to become amplified to disease-level proportions. Hence, the small—and as far as we know, only—act of violence which Jack has exhibited toward Danny *before* going to the hotel, is there amplified like a resonant feedback loop into homicidal aggression. And the same goes for Wendy's uncomfortable attempts to play the role of an encouraging muse for Jack, which he—for some reason that is never specified—resents and which is also amplified into homicidal aggression during their stay at the hotel.

Now, the significance of Danny's vision of the blood pouring out of the elevator is that Tony is showing him the "lifeblood" of the hotel as though it were a living organism. This is the blood that the hotel lives upon, that courses through the veins of its hallways and pulses at the heart of its very being and which is fed to it from the human sacrifices that occur in the hotel. (Stephen King once wrote a Prologue to his novel entitled "Before the Play" that was deleted from the final cut, but which detailed the many murders and suicides that have taken place in the Overlook since its founding in 1907-09).[24]

The idea is a feature of Mesoamerican cosmology, for *the fuel that ran their civilization, from the Olmecs to the Aztecs, was human blood, any blood*. For the Mayans, if you wanted to call forth a dead ancestor in order to get the ancestor to do your bidding for you, then you had to draw blood in some manner from your body, whether piercing a needle through the center of your tongue or using an obsidian knife to cut your genitals. The ancestors would only come forth if human blood was offered to them, and if it was offered, then a Vision Serpent would appear, open its jaws, and out would spring the head of the dead ancestor who would then ask, like a genie, what the summoner wanted.[25] Later on, in Aztec civilization, of course, the idea was amplified over time like an initial error in the system that resulted in bigger and bigger consequences as the system unfolded, and entire industries of the cutting off of heads and cutting out of hearts at the tops of their pyramids in order to offer blood to the sun god became that particular civilization's "accursed share," as George Bataille puts it in his book on *The Accursed Share*.[26]

And the same goes, likewise, for the Overlook Hotel: it is to be thought of as a sort of living organism that thrives only

on the blood of human sacrifices that must be constantly fed to it as the result of its being constructed over an Indian burial ground and forming, therefore, a kind of portal or gateway to the land of the dead.

It is an old idea, present even in the descent of Odysseus to the Underworld in *The Odyssey*, that the dead will only appear if fresh blood is offered to them.

Ascent Redux
(17:38 – 19:40)

Another helicopter shot now carries the viewer over the mountains looking directly down at Jack's VW bug once again as it crawls along a narrow strip of gray highway that has been chiseled out of the mountainside by some mighty architect. This time he has brought Danny and Wendy along with him, for they are now ascending to the Overlook on its "Closing Day," as Kubrick's title card indicates, to take over the responsibilities of maintaining its "organic" functions for the rest of the winter (typically, in the ancient rituals and traditions, this time of year is the beginning of the season of the rise of ghosts and spirits from out of the Underworld. Indeed, it is very possible that they are driving up to the hotel on either Halloween or the day before it, since Ullman has already explained to Jack that the hotel closes on October 30th). The scene is scored with an original synthesizer composition by Wendy Carlos and Rachel Elkind, which gives it a moody, Otherworldly feel like something out of an Eastern European classical avant-garde composition or even a painting by Zdzislaw Beksinski (as though they were ascending to a sort of castle in the clouds).

Inside the car, Danny sits in the backseat with his mother on the passenger side, but he sits forward between his parents so that he is almost standing as he complains about being hungry. Jack tells him that he should've eaten his breakfast before they left Boulder, but Wendy assures him that there will be food at the hotel. There is a momentary silence and then Wendy wonders aloud whether this was about the area where the Donner Party got stranded. Jack tells her that that was further west, in the Sierras—although the party *did* travel over the Rockies on their way west--and when Danny wants to know what the Donner Party was, Jack explains bluntly that it was a party of settlers in covered wagon times that got trapped in the snow one winter and had to resort to cannibalism in order to survive. Wendy chides him for his bluntness in front of Danny, but Danny reassures his mother that he has already learned about cannibalism from television.

The reference to the Donner Party is an interesting one, for it forms a parallel to Kubrick's narrative: the Donner Party was part of a group of emigrants that left Springfield, Illinois in April of 1846, convinced by a lawyer and developer named Lansford W. Hastings of a new and shorter route that would lead them across the continent to California within four to five months. But the route had never been tested, not even by Hastings himself, and turned out to be a disaster. Hastings had had dreams of conquering California and transforming it into a Republic and he convinced the emigrants that this could be done bloodlessly simply by settling there, and so the emigrants set out with dreams in their heads of creating a New Land (California was, however, taken from the Mexicans by the United States government during the Mexican-American War of 1846-48, and incorporated into the Union in 1850).

Nearly five hundred wagons set out west from Independence, Missouri on May 12, 1846, but the party split into two groups along the way, for on July 20, at the Little Sandy River in Wyoming, most of the group opted to follow the established—and therefore, safer trail--via Fort Hall. But the Donner Party, as it came to be called—since George Donner was elected captain--chose the untried Hastings route to the south and suffered grueling misfortune shoving their wagons up over the Wasatch Mountains in Utah, only to follow that ordeal with an even worse one crossing Utah's Great Salt Lake Desert in the middle of the summer, whereupon they lost most of their cattle and oxen, which either died of thirst or ran away, desperate for water. The desert turned out to be *twice* the distance which Hastings had told the party it would be and as a result, it took them over a month to cross it. They were anxious to reach the Sierra Nevada mountains before the winter snows began—which would block the pass--but they arrived at the foothills of the Sierras just as the snows were building up into the worst winter in recorded history at that time.

The party remained snowbound for four months at Lake Truckee, high up in the mountains, and slowly, reluctantly began to resort to cannibalism as their numbers died of starvation or froze to death. Of the 87 members of the party, 48 survived to reach their final destination as the result of a series of four rescue parties that were sent to fetch them over the course of six or seven weeks between February and April of 1847.[27]

Hence, Kubrick *folds* the Donner story into his narrative simply by referencing it, for both the Donner Party and the Torrance family set off naively into the Transcendence of the Western mountains thinking that the task in front of them will be manageable, if not easy. In both cases, the result is

isolation, seclusion and madness, with the asymmetry of the Donner Party resorting to physical cannibalism during a terrible winter, while Jack Torrance, in the role of Saturn devouring his children, resorts to a kind of psychological cannibalism during a severe winter in the Rockies. Kubrick's and King's narrative—for King references the Donner Party in Chapter 8 of his novel--resonates with the history of the West's dreams of conquest through ascent from the Great Plains to the transcendence of unattainable dreams and ideals in the mountainous West, for the Rockies function almost like a gigantic natural geological Great Wall separating the western half of the United States from the flatlands of its eastern half. The migrations West which were accelerated during the Gold Rush of 1848-1855 eventually resulted, not without a certain degree of irony, in the creation of Los Angeles as the city of realizing fantasies, and Las Vegas as the ersatz city of the Siren Song that calls its victims onward to financial debacle and ruin.

The disaster that befell the Donner Party during four months of winter is a foreshadowing of the disaster to come that will befall the Torrances during another similar severe winter lasting for approximately the same period of time.

The First Sighting
(19:41 - 22:15)

In the next scene, Stuart Ullman and Bill Watson approach Jack in the hotel lobby and tell him they have just enough time to give the Torrances a quick tour of the hotel. Jack says that his son has discovered the games room and that he'd better collect his family for the tour before they begin. In the scene that follows, Ullman, Watson, Jack and Wendy are stepping out of an elevator onto the second floor and into the hotel's Colorado Lounge, a large, almost cathedral-like space with stained glass images in the windows not of Catholic saints but of Navajo and Apache spirit designs. The room is an important stage setting for much of what follows in the film, for it is in this room that Jack will sit and attempt to write his novel and it will be at the top of its staircase that he and Wendy will first confront each other violently.

The scene then changes to the games room, where Danny has been throwing darts at a dartboard. Kubrick has Gyorgy Ligeti's *Lontano* (1967) playing on the soundtrack to this scene, which gives it a nervous and atmospheric tension.[28] When he goes to collect the darts from the dartboard, Danny feels a presence behind him that causes him to turn his head

abruptly. In the doorway to the games room, there stand the two little girls, ages 8 and 10, who had been murdered by Charles Grady in 1970 (although Ullman has specified the difference in their ages, the girls were actually played by identical twins, the actresses Lisa and Louise Burns). They are identically dressed in checked-blue dresses, black shoes and high socks and they stare wordlessly at Danny for a moment before turning their heads to look at each other, whereupon they smile as though at some shared secret and, in perfect synchrony (like Siamese twins), walk out through the doorway, leaving Danny visibly frightened.

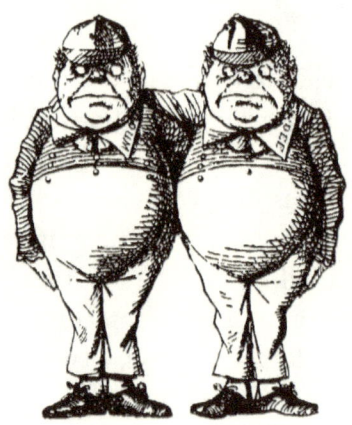

The two girls at first remind one of the character of Alice from Lewis Carroll's two novels about her. A double of Alice even appears at the beginning of the second book, *Through the Looking Glass*, when Alice, wondering what might be on the other side of a mirror, climbs up on the mantel and looks at herself in a mirror, then steps through it into the other side, which forms a strange parallel universe to the real world. The twins, in Kubrick's film, furthermore, remind one of the pair of twins that Alice encounters in that other world, Tweedledum and Tweedledee (shown above), who are

pictured by the artist Tenniel not clasping hands as the girls in *The Shining* do, but with their elbows over one another's shoulders. They, too, are dressed identically.

But from the film's very first image of the scenery of the Rocky Mountains reflected in the mountain lake in the opening image there has been a "doubling" motif present throughout. When Danny was shown brushing his teeth, he too, like Alice, was looking at an image of himself in the mirror while talking to his "double" named Tony. (Note that the name "Daniel" comes from the Jewish world in *The Book of Daniel*, a man gifted with prophetic abilities, whereas Tony, or Anthony, comes from the classical Roman world, as in Marc Antony. Hence, the two cultures affiliated with the Northern European culture, and which gave birth to it, are acknowledged. The Northern West's dual apparentage has survived clear down to the present day as an unresolved fault line running down the middle of its collective consciousness.)

Jack Torrance has a double, too, in the form of the earlier caretaker Charles Grady who killed his family with an axe, just as Jack will attempt to do. The two families are themselves doubles of one another, although they are asymmetric, since the first is composed of Charles "Delbert" Grady, his wife and two daughters (hence, a quaternion), while the present concern of the narrative is a triad of Jack, Wendy and Danny, their asymmetric mirror image.

In the ascent to the top of the mountain, the Torrances have indeed gone *through* the looking glass into a reality that parallels and mirrors the real world, but does so in distorted fashion, just as Alice's two cats, a black kitten and a white kitten, appear on the other side of the mirror as a pair of queens, the Red Queen and the White Queen. The twins, Tweedledum and Tweedledee inform her, moreover, that the sleeping Red King is dreaming *her*, Alice's avatar on the

Other Side, and that when he awakes, she will cease to exist, which is exactly how the novel concludes.

Two further points: *The Shining* is a story that postulates the idea that places have memories, just as people do. And indeed, it has been theorized that ghosts are really "memories" engrained in particular places where traumatic events once occurred, for it is as though buildings, or places where battles took place, etc. absorb the energy of human traumas and violence and actually store that energy in some type of subtle form in those areas that mediums, for example, are able to gain access to. *Places have memories, then*: that is the thesis of both book and film. Furthermore, the memories engrained in particular places can become so strong that human beings can unconsciously "pick up on" and "tune" them in and even end up reenacting them again in the world of physical space-time. This is perhaps why places where violence has occurred repeatedly give some people an unsettled feeling, for they are unconsciously "remembering" what has occurred there. Such events can cause "chreodes" or runnels in the very fabric of space-time that can act as morphic shaping fields into which the behavior patterns of certain individuals can simply fall into alignment with, and the more unconscious they are, the more they repeat the same events, over and over again. (The long, long history of violence in the Middle East, which seems impossible to eradicate, may be an example of this).

The other point is the myth motif which the girls seem to represent: they are so closely entwined together that they resemble a two-headed figure, and indeed, the motif of the two-headed goddess—one symbolizing life and fertility, the other death—is a motif that goes way, way back into the Neolithic where statues of two-headed goddesses have been found at places like Catalhoyuk and Ain Ghazal (a two-headed goddess from Ain Ghazal circa 8000 BC is shown

below). Later on in the evolution of culture, the two-headed goddess became separated into two distinctly different figures, as they are already at the "dawn of history" in Sumer where they became Inanna, the Mistress of the Great Above, and her sister Ereshkigal, the Mistress of the Great Below. By the time they arrived in Greece, of course, they had become Demeter, the goddess of grain, and her daughter Persephone, abducted by Hades and carried down into the underworld to become his bride for the winter.

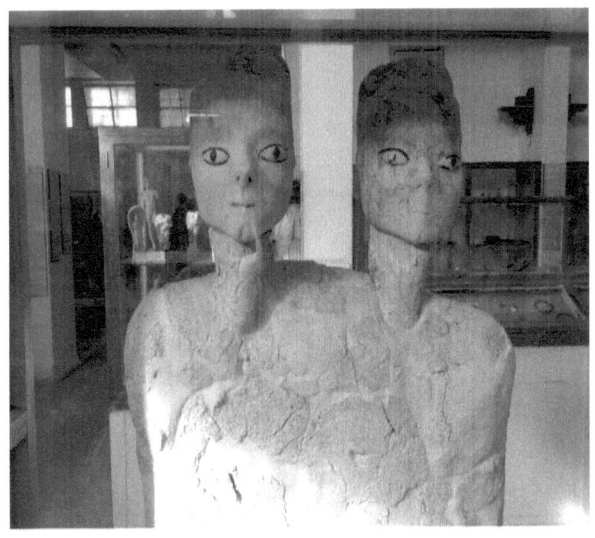

The Tour
(22:16 – 28:52)

Stuart Ullman has taken Jack and Wendy upstairs to the staff wing, as he calls it, in order to show them their living quarters. Two staff women, both blondes, are coming down the steps carrying luggage and Ullman bids them goodbye (note how they reiterate the motif of the double-headed goddess from the previous scene, only now they are completely separate entities, as though to retrace the cultural history of that motif in miniature). Ullman then guides Jack and Wendy through their living quarters, pointing out the amenities, Danny's room, etc. The Torrances seem pleased.

The next shot is an exterior scene outside the hotel that shows Ullman and Bill Watson with the Torrances between them walking past the hedge maze. It is a labyrinth with walls that are thirteen feet high, and Ullman warns them not to go in there unless they have at least an hour to spare finding their way out. He says that it was built at about the same time the Overlook was constructed in 1907-09 over an Indian burial ground and that the builders actually had to repel a few Indian attacks while it was being built. He then guides them to the garage and tells them about the snowcat,

a vehicle with tank treads that can be driven just as easily as an automobile.

Labyrinths, it should be remarked, are in origin associated with the underworld and the land of the dead. They seem to have originated amongst the ancient Egyptians, who designed the underground burial chambers of their pyramids—beginning with the first great stepped pyramid of the Third Dynasty pharaoh Djoser—in complex passages in order to keep grave robbers *out*. As the evolution of the pyramids progressed from the Old Kingdom to the Middle Kingdom, the labyrinthine designs kept getting more and more complicated as grave robbers kept figuring them out. The tomb labyrinths eventually separated from the tombs themselves in the Middle Kingdom to become ever more and more complicated, and the most famous and elaborate of them all was the temple complex of the pharaoh Amenemhat III (c. 1860 BC – 1814 BC) associated with his pyramid at Hawara, near the Faiyum and which was known to the ancients as "the Labyrinth."

The famous labyrinth supposedly built by Daedalus for King Minos at the palace city of Knossos was constructed not to keep anyone out, but rather to keep the Minotaur *in*. Indeed, the design was said to have been so complex that Theseus, when he arrived, required the aid of the king's daughter Ariadne, who advised him to use a ball of thread to mark his passageway going in so that he could then retrace it to find his way back out. In reality, the mythical labyrinth was probably the way cultural memory has remembered the complex architecture of the palace city of Knossos to the later Greeks, for it was laid out in an intricate design of twisting and turning corridors and hallways around a central plaza where a bull sacrifice is thought to have taken place. Crete, furthermore, was associated by the Greeks with

the land of the dead, for both King Minos and his brother Rhadamanthys, after their deaths, became judges of the dead in the underworld of Hades.

In the Medieval period, the labyrinths laid out on church floors—such as the one at Chartres—became associated with penance. The penitent man had to trace his way through the contours of the labyrinth in order to arrive at the center, where he would find either heaven or Jerusalem or even, perhaps, a saint as his reward.[29]

In any event, it should be noted and remembered as *The Shining* unfolds, that labyrinths are typically associated with the realm of the dead, and also with the housing of monsters.

As the tour continues, Ullman leads the Torrances into the hotel's Gold Ballroom, where he informs them that they won't be able to have any parties here unless they've brought their own supplies, since they get rid of all the liquor from the premises for the winter in order to reduce the insurance they have to carry. Jack points out that the Torrances do not drink and Ullman then tells them that they're in luck.

The Torrances are then introduced to Dick Hallorann, an African-American who happens to be the hotel's head chef. Then, as if on cue, Danny is brought into the ballroom by an older woman who claims that she found him outside the hotel looking for his parents. Ullman then hands Wendy and Danny over to Hallorann so that Hallorann can show the vast kitchen to Wendy, while Ullman and Bill Watson will then continue on with Jack.

The scene then changes as the camera follows Hallorann, Wendy and Danny through the enormous silver and white kitchen area. When Hallorann asks Danny what he thinks about the size of the hotel, Danny tells him that it's the biggest place he's ever seen. Wendy then says that the place is such a maze that she feels like she will have to leave a trail

of breadcrumbs every time she comes into it.

The reference to the trail of breadcrumbs not only subtly alludes to Theseus using a ball of string to find his way out of the labyrinth, but also, more specifically to the Grimm's fairy tale of Hansel and Gretel, in which a mother tells her woodcutter husband that their two children are eating too much of their food and that they are in danger of starving to death, so he should lead them out into the woods and abandon them there. The children overhear the conversation, so Hansel gathers up pebbles and as the father leads them into the labyrinth of the dark and murky German forest, Hansel leaves a trail of pebbles behind them. When the moon comes out, the two children then follow the pebbles back to the house, much to the consternation of their mother who then insists that the father must lead them even further into the woods on the next day. This time, the children have been locked up, so Hansel has no access to pebbles, but he does grab a piece of bread on the way out the door and leaves a trail of breadcrumbs behind as the father leads them even deeper into the forest and abandons them. When Hansel and Gretel try to find the breadcrumbs, they discover that birds have eaten them and that they have no way out of the forest. But they follow a mysterious bird that leads them to a gingerbread house from which they hungrily break off pieces and begin eating. The witch who lives there, however, is a cannibal ogress, and invites them inside with promises of food, but then locks them up and prepares to cook and eat them. They eventually outsmart the witch and escape, as is well known, but it is clear that the dark German forest—perhaps the Black Forest is meant—is thought of as a labyrinth at the center of which is found, not a Minotaur, but another sort of monster: a cannibal witch who takes a special delight in eating young children.

In *The Shining* the cannibal witch will turn out to be the rotting and putrescent woman in room 237 who attempts to strangle Danny, but it is Jack Torrance himself who will wind up trapped inside the labyrinth in the role of the Minotaur. The trail of breadcrumbs and the ball of string is traded out by Danny's footsteps in the snow, which he retraces in order to find his way back out of the hedge maze at the end of the film.

In the present scene, the gingerbread house made out of candy—with its promise of endless stores of food inside—becomes the walk-in freezer full of meats in the kitchen of the Overlook Hotel, and more especially, the large walk-in dry goods storage unit. A trap is being laid for the Torrances, in other words, a trap in which the illusion of plenty—which contrasts strikingly with the empty liquor shelves in the Gold Ballroom—acts like bait to lure them into a sense of false security.

When they come out of the freezer, Wendy wants to know how Hallorann knew that both she and Jack sometimes refer to Danny as "Doc," from the Bugs Bunny cartoons, but Hallorann skillfully dodges the question by imitating the famous rabbit in front of Danny.

In the dry goods storeroom, which they enter next, while Hallorann is enumerating all the items, Danny receives his first telepathic communication from him--a "shine" in other words--in which he asks Danny if he'd like some ice cream.

When they emerge from the dry goods storage larder, Ullman, Watson and Jack meet up with them and ask to borrow Wendy as they continue down to the basement where the main boilers are located. Hallorann says he'd be delighted to sit down and have some ice cream with Danny, who does not object, and tells Hallorann that chocolate ice cream is his favorite.

It is significant that Hallorann is African-American, for he is here in the role of the traditional "nannies and grannies" who know all the lore and stories that are either repressed or censored by the traditional ruling authorities in a household (especially in the American Deep South during the times of slavery, when such stories as Bre'r Rabbit and the Tar Baby were passed along to the children). In Europe, when the Grimm brothers went looking for the best sources for recording their tales, they found them in the elderly grannies who knew the stories by heart and told them to their children at bedtime, possibly giving them nightmares in the process.

Thus, as far as knowledge of "those who shine" goes, it is best recounted by those who come from an earlier and much older--and also socially "lower" sign regime--one that was later overcoded by the white man to form such hybrid media as rock 'n roll and forms of dancing such as the Charleston. And so the scene is set for the conversation between Danny and Dick Hallorann that now follows.[30]

Thus, the film's sign regime is a mixed one that replicates the American sign regime perfectly: a hybridization of ancient Native American deities and spirits overlaid with a *second* sign regime of black folk culture which, in turn, is inscribed and overcoded by an emigrant white European sign regime that then becomes, over the centuries, *undermined* and *re-coded* by the other two to produce that hybrid sign regime known to the entire planet today as American Pop. Thus, Native American deities and heroes such as Spider Man and Batman eventually rise to the surface in the form of comic book superheroes, while African tribal dancing and singing lays out the template for the birth of jazz and rock 'n roll.

The Conversation
(28:53 – 34:10)

Ullman, Watson, Jack and Wendy are walking down the corridor that leads out of the kitchen—passing *precisely* the metal cabinets where Danny, at the film's climax, will crawl inside in order to hide from his homicidal father—and Ullman is explaining to them that all the guests had left on the previous day, and that by five o'clock this evening, the staff will be gone, too. This strongly suggests that the day before would have been October 30^{th}, the last day on which any guests could stay in the hotel, while the present day must then be October 31^{st}, or Halloween, the day when all the staff are required to clear out. Thus, the Torrances have arrived at the hotel on the day when, in the Western tradition, anyway, the temporal gateway to the underworld was opened up and all the dead—in the form of masked children wearing costumes—are unleashed from the World Below.

The scene now shifts to the conversation between Hallorann—whose name does sound a little like "Halloween"—and Danny at the kitchen table in which they have been eating chocolate ice cream. Hallorann tells

Danny that he knew his nickname was "Doc," because he has the power which his grandmother called "shining." He tells Danny further that he and his grandmother used to have entire conversations without ever even opening their mouths.

Stephen King says that he derived the book's title from the John Lennon song, "Instant Karma," and specifically from the lyric that goes: "well, we all shine on." But the fact that Hallorann points out that he had telepathic conversations with his grandmother, in which neither of them needed to use their mouths, reminds one of the insistence of the Swiss philosopher Jean Gebser that in the magical consciousness structure of tribal man, there exists a "mouthless" motif that can be found in their art, as for example in the case of Australian aboriginal paintings of their Wondjina ancestor figures (shown opposite). Gebser equates the word "mouth" with "myth," and insists that the mouth did not become an important structural feature of human consciousness until the advent of the mythical consciousness structure sometime during the later Neolithic when all the statues of the artwork come equipped with clearly defined mouths (compare, for instance, the creepy ancestor statues, made out of clay, of the Neolithic Middle Eastern site of Ain Ghazal, from around 7000 BC, in which some, but not all, of the examples, exhibit mouths).[31] By the time of the ancient Egyptians, there was an entire ceremony dedicated to the resurrected mummy—known as the *sahu*—entitled "the Opening of the Mouth," which conferred upon the dead spirit the ability to speak once more, so that it could recite the proper incantations and spells against the various demons and locked doors that it would encounter on its way through the labyrinthine passages of the underworld, known to the Egyptians as Amenti.[32]

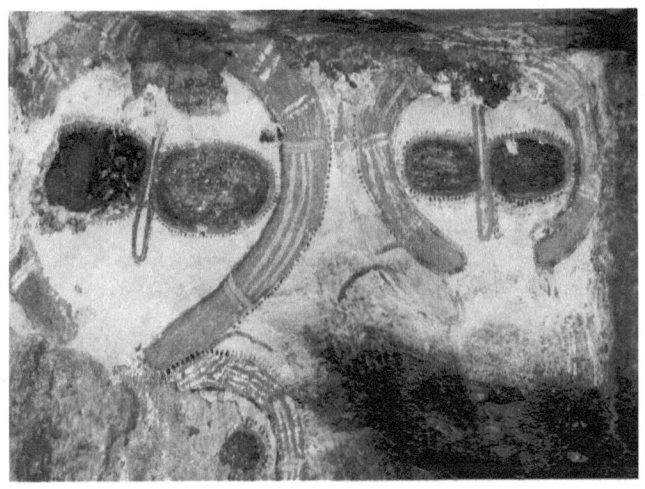

When Danny seems reluctant to talk about his abilities, Hallorann asks him why he doesn't want to talk about "shining," and Danny explains to him that Tony has forbidden him to discuss the power with anyone. When Hallorann asks about Tony, Danny tells him that he is the little boy that lives inside of his mouth but who communicates to him through showing him pictures and images in his head that cause blackouts.

When Danny asks Hallorann if he is afraid of the Overlook Hotel, Hallorann insists that he really isn't, but that certain places, such as the Overlook, are like people: some shine and some don't. Danny then asks him whether there is anything "bad" in the Overlook, and Hallorann tells him that sometimes events can leave traces of themselves behind, traces that people with the ability to shine can notice. (Hence, the narrative's thesis that places can have memories just like people can have them).

Danny then asks Hallorann about Room 237, and Hallorann tells him firmly that there is nothing in that room

that need concern Danny and that he should *stay out* of it. Later we will find out that it is the room containing Jack's muse and that it has hostile intentions toward any and all of Jack's creations, be they biological or literary.

In the book, the equivalent room is Room 217, the very same room in which Stephen King stayed at the Stanley Hotel in 1974, but Kubrick changed it to Room 237 since the Timberline Lodge on Mount Hood, Oregon, which forms the basis of the film's exterior shots, does not have a Room 237, and its proprietors were afraid that guests wouldn't want to stay in their Room 217, so they requested that Kubrick change the number and he complied.[33]

It is interesting, though, that its numbers, 2 + 3 + 7 add up to 12, an even number which therefore has a feminine valency in the classical Pythagorean tradition (whereas odd numbers are assigned a masculine valency). The number 12, furthermore, is zodiacal and suggests something cosmic. The room's female occupant, like the Grady twins, also has two heads: a young and fertile female visage which, in the mirror, is transformed into the decaying body of an old hag. Likewise, in the ancient Sumerian tradition, both Inanna and her sister Ereshkigal were cosmic, too, for Inanna—the young and beautiful patroness of sexuality—was associated with the planet Venus, while Ereshkigal was the mistress of death and the underworld known to the Sumerians as Irkalla. In the story of "Inanna's Journey to the Underworld," Inanna descends down to her sister's domain and must there undergo "death," in which her decaying corpse is hung upon a hook on the wall of her sister's house of Death.[34]

Waking Up
(34:11 – 37:33)

The title card for this next sequence reads "A Month Later," (which puts it at the end of November, just ahead of the main snow season in Colorado) so we are to intuit that the Torrances have now settled into their various respective routines. Immediately following the title card, there is a beautiful second unit shot of the Timberline Lodge with an empty parking lot, save for Jack's lone yellow VW bug, already emphasizing the family's isolation from the rest of the world. Indeed, the film's series of exterior hotel shots in various conditions of light and times of day is almost Kubrick's equivalent to Monet's series of paintings of Rouen cathedral which he painted in the 1890s and which capture the west façade of the cathedral from the same angle, at different times of the year and day.

Interestingly, the Timberline Lodge, like the traditional orientation of cathedrals, is laid out on an East-West axis at the foot of Mount Hood, and in the present exterior shot, the fresh morning sunlight is painting the eastern wing of the hotel a bright lemony yellow. Smoke is puffing from the hotel's eastern fireplace and everything is up and running.

The next shot then tracks Wendy coming from the hotel's kitchen pushing a cart with Jack's breakfast carefully laid out to his specifications. The camera follows her through the hotel's (now darkened) main lobby, past the model of the hedge maze on the right and the front desk with Ullman's office behind it on the left.

The next shot then cuts to Danny on his tricycle using the famous Steadicam (invented by Garrett Brown in 1975 and then re-invented specifically for Kubrick's film), and which now follows him, as though floating from behind. This establishes two things: one is that, looked at from the perspective of a child, the Overlook Hotel is itself a gigantic labyrinth full of corridors, dead ends, and murky hallways that lead into dark recesses and alcoves. The Overlook *is* a labyrinth inside which the Torrances are now trapped for four more months without realizing that it is, in fact, a trap.

The second thing that the Steadicam shots establish is the eerie sensation that spirits might be following Danny around. He is not as alone on his tricycle as he thinks he is, and the hotel's ghosts are well aware of his presence as they eye him for the potentialities of his "shine" powers. Danny is like a medium who does yet know that he can communicate with the dead, but the dead know it very well and they are anxious to use him as a means of communicating with the living.

In the next shot, Wendy is exiting from the elevator to the floor of their private apartment, where the walls are painted sky-blue. She opens the door to their room, and the scene immediately cuts to a shot of Jack sound asleep in bed, although—significantly—it is a mirror image of him (the second of the film's many shots of mirrors). The camera pulls back to show Wendy uncovering the food for Jack, who is at her left, but the camera then drifts back toward

the mirror on Wendy's right to show Jack sticking out his tongue. Though it may seem innocuous enough, the motif of the sticking out of the tongue is a common one among Native American shamans, especially those of the Northwest Pacific Coast. Tongues, in this tradition, carry power, for the spirit animals who appear to the shaman stick their tongues out at him, and he cuts them off. Masks are then made depicting the power over the spirit-animal world that the shaman carries by sticking out his tongue (see image below). The significance in this scene is the first, earliest hint of Jack's transformation into a two-dimensional spirit being. It is, furthermore, a motif from the film's Native American sign regime.[35]

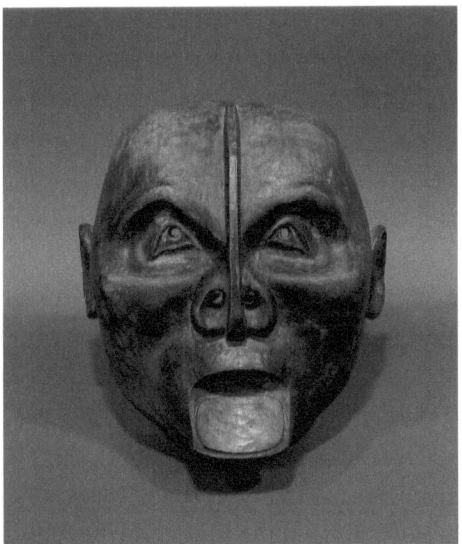

As Wendy serves Jack his breakfast in bed, she tells him it is nice outside and suggests that maybe he could take her for a walk after his breakfast (already indicating her loneliness). Jack tells her, though, that he should do some writing first, and when she asks if he has any ideas for his book, he says he

has lots of ideas, but no good ones. In other words, from the moment he has arrived at the hotel he has been afflicted with writer's block, which has continued for an entire month. There is, then, a problem with his relationship to his muse, since as I've suggested, Wendy does not function well for him as a muse, though she desperately tries to play that role for him. The Overlook Hotel is a place of stagnant spiritual energy and inertia, full of ghosts and "residual" events from traumatic episodes in the hotel's past. It therefore contains an energy field that is mired in the past, whereas creativity always points toward the future. The Overlook Hotel is not at all what the Torrances thought it would be, for it is a place with its own mind that strangles all creative projects, since the weight of the past acts with all the inertia of a black hole on anyone who stays there for a lengthy period of time.

In fact, when Jack explains to her, while eating, how much he loves the Overlook Hotel—the camera now shifts from the mirror image to the "real" Jack—he tells her that when he first came up for the interview that it was as though he'd been there before, almost as though he knew what was going to be around every corner. This comment is a foreshadowing of the film's final image, in which the camera closes in on a black and white photograph of the hotel taken in 1921 which clearly shows a young Jack present amongst a crowd of revelers. Kubrick's idea is that Jack has been reincarnated: he was present at the hotel in a former lifetime, and his karma has brought him right back to it in his next lifetime during the 1970s.

Once again, this reiterates the inertial presence of the past and its dominance on Jack's consciousness, a weight so heavy that it stifles his creativity and pulls him back over its event horizon into merely repeating actions that he has already done before.

The Hedge Maze
(37:34 – 40:28)

It is presumably the same day upon which this next sequence occurs, which takes place in the vast Colorado Lounge and begins with a shot of Jack's old fashioned typewriter with a blank sheet of paper inserted into it and a burning cigarette left still smoking in the ashtray to the right of it, and a pack of Marlboro cigarettes to the left. As the camera zooms out, there are piles of magazines littered on the coffee table in front of the couch, as well as splayed about on the couch itself as evidence of Jack's restless search through magazine articles for ideas to write about. Needless to say, he isn't having any luck, and as the camera continues to pull back, Jack is shown throwing a tennis ball against the wall and catching it repeatedly as it bounces back at him. Significantly, the art on the wall depicts Navajo corn beings, and so they are images of the very abundance that Jack Torrance is precisely *lacking*. Hence, his antipathy to the "spirits."

Since Jack wouldn't take her out for a walk, Wendy has decided to bring Danny with her into the hedge maze, and the next shot is an exterior one that shows mother and child heading excitedly for the labyrinth. The map of the hedge

maze, printed on stained and ageing vanilla paper at the entrance, shows that it is laid out in the shape of a rectangle with a horizontal axis. The camera follows Wendy—who is once more wearing red and blue, in this instance a red jacket over a blue outfit—and her son through the maze as they turn and navigate its right-angled hedge corners. Indeed, right angles are everywhere: there are *no* curves present in the maze whatsoever. It is therefore a masculine construction of the ratiocinative intellect, located in the brain's frontal lobes, a construction that requires *figuring out* just like solving a puzzle or building a machine. (Kubrick scores this sequence with Bela Bartok's 1936 composition *Music for Strings, Percussion and Celesta*, borrowing a piece from its nervous third movement, or "Adagio," which adds a great deal of tension to the scene).[36]

The film then fades back to Jack wandering around the hotel's reception area, still throwing his tennis ball in frustration against the walls of the hotel. He spots a scale model of the hedge maze and wanders over to it (passing the baseball bat that is resting on a small couch to his right that he must've been using at some point to hit the tennis ball with, for it is the same bat that Wendy will later use in the film to "play" with Jack, understanding that word with all the sinister connotations which the Grady twins will use when they later ask Danny to "come play with them"). Jack now stands at the model of the hedge maze, where he is looking down at it from a *vertical* axis, pondering its complexity. The scene is then intercut with a view looking down at the hedge maze from high up in the air, where it is shown once again on a horizontal axis, *although it is a different, much more complex maze* that does not correspond to either the the map at the maze's entrance *or* the model that Jack is contemplating.[37]

What the monolith in *2001: A Space Odyssey* was to that film—namely, its central enigmatic signifier—so too the hedge maze is *the* main signifier in *The Shining*. Its labyrinthine folds—especially when viewed from high above—remind one of the intricate layers of folding tissue in the human brain, itself a kind of labyrinth. The hedge maze, then, is the *brain* of the Overlook Hotel itself, just as we have already seen the blood from its pumping heart in Danny's vision inside the bathroom of the Boulder apartment.

It is, moreover, a kind of template that the Overlook Hotel is insidiously using to *invade* Jack's consciousness with a grid that freezes up all his creativity. A maze is completely rigid, petrified and unmoving, except for those who either physically or mentally move through its contours, and it is being inserted into Jack's mind by the consciousness of the hotel itself, causing his frontal lobes to rigidify and lock into stasis. Creativity is invariably depicted as a flowing, pouring movement—think of Mozart composing his symphonies in Milos Forman's *Amadeus*--as in the case of what Jean Gebser calls the" soul's life pole," which is always associated with the Muses and various bodies of flowing water, such as springs, fountains and rivers. (The "soul's death pole," on the other hand, is always winged, like the various Harpies, angels or Egyptian *ba*'s that hover around graves: the aerial view over the labyrinth does suggest the point of view of a winged spirit looking down).

The hedge maze, furthermore, is the trap inside which Wendy and Danny are caught on the *inside* of Jack's mind. Though he is not consciously aware of it yet, they are his intended victims, and they are trapped on the inside of his mind, where he will hunt them down (as he does literally at the end when he chases Danny through the snow-covered maze).

Kubrick, furthermore, retrieves for this scene an ancient pre-perspectival age aesthetic in which each object occupies *its own* space separate from each other object, so that certain entities which are spiritually more significant—such as pharaoh or Christ or the Virgin Mary—are scaled up in size relative to all the other entities in the composition. Just as the hedge maze is here shrunk down to 0 scale (that is to say, about the size of the standard railroad model train set), Jack, in relation to it, is scaled *up* like the giant Alice after taking the pill that makes her too large to fit inside the house she finds herself trapped in. Jack is plugged here into the role of a giant, like the giant in the fairy tale of "Jack and the Beanstalk" who pursues the tiny child who flees up and down the beanstalk as a central axis of connection to the spirit world. Jack is here in the role of a huge, monstrous ogre, who is slowly beginning to direct his creative frustration into homicidal rage at his wife and child, whom he perceives as being somehow responsible for the blockage of his creativity.

The scale model of the hedge maze, then, has an entirely *opposite* semiotic significance to the Navajo corn deities on the wall, who are spirits of fertility and abundance, whereas the maze is an artificial construction of the brain's frontal lobe that is now being inserted into Jack's mind as a grid which, from henceforth, will *block* all further creativity. The Overlook Hotel will slowly convince him that the only way to *unblock* that creativity will be to destroy his wife and child.

The Interruption
(40:29 – 45:59)

The title card for the next sequence reads "Tuesday," and takes place perhaps a couple of weeks later. It begins with another second unit shot of the Timberline Lodge from the exact same angle as before, only it is twilight and the hotel is painted in varying shades of purple and magenta. One room on the hotel's east wing is lighted—perhaps the kitchen—while two windows on the second floor of the west wing are glowing with a soft electric incandescence (perhaps the Colorado Lounge, which is located on the second floor).[38]

Wendy is then shown in the hotel's gigantic kitchen preparing a meal as she struggles with a can opener to open a huge can of fruit, while a nearby television is playing the evening news, giving forth various grim announcements, such as the continuing search for an Aspen woman who mysteriously disappeared while on a hunting expedition with her husband. (There is a possible implication that her husband murdered her, which would be a foreshadowing of the events to come). Then, the weather forecaster announces ominously that a huge snowstorm is approaching Denver from the north and the west, signaling the beginnings of the

Torrances' three and a half month long isolation due to road closure leading up the mountain. From this night forward, they will be completely cut off from contact with the outside world.

Next comes a tracking shot that follows Danny on his tricycle once again, only this time he is on the hotel's second floor riding down its brightly lit corridors with the orange honey-comb designs on its carpet. (He, too, is now wearing red and blue: a red shirt with blue overalls). He passes by the double doors of Room 237 and stops, looking back over his left shoulder—the left is always the sinister side, remember—wondering about what mysteries the room might contain. (Once again, Kubrick scores the scene with a few more minutes from the third movement of Bartok's *Music for Percussion, Strings and Celesta*). Danny cannot help himself and so he gets off his tricycle and walks up to the door of Room 237 and carefully tries the handle (it is locked *this* time, fortunately). A fleeting vision of the Grady Twins, dressed in their blue-checked dresses, flashes for some reason through his mind, and he thinks better of it and runs to his tricycle and pedals away as fast as he can possibly manage.

As Bartok's piece winds down, the scene then changes to the Colorado Lounge, where the camera is creeping up on Jack from behind, who is busily typing away at its huge table. (Notice how Kubrick's camera is always approaching his characters from behind them as though to indicate that they are being *watched*). The Lounge is crawling with shadowy evening lamplight while Jack types away, finally in a creative flow at last. A scrapbook of newspaper articles is opened to the right of his typewriter, so he is not yet writing the repetitive sentence over and over again that he will later write in a fit of insanity. He has managed to find *some* kind of project to work on, and he is in creative flow

when Wendy appears through the archway to his right and begins to approach him. (She is wearing a blue dress with red stockings).

She says hello to him and kisses him on the mouth just after he has ripped the page from the typewriter in agitation that she has interrupted his creative flow. She asks him whether he's gotten a lot written that day, and he gives forth a moody and laconic "yes." She then tells him that the forecast is for snow that night and, still irritated, he asks her what she'd like him to do about it. She replies that he has no need to be grouchy, and he counters by snapping at her that he is not being grouchy but that when she interrupts him while he is writing it then takes him time to get back to the point where he left off (as all writers know, Jack is not being unreasonable here; interrupting a writer in creative flow is generally a bad idea).

Being conciliatory, she offers to return later with a couple of sandwiches for him and hopes that he will then have something for her to read, but this only seems to make him angrier. He tells her that they are now going to make a new rule: that whenever she hears him in the Lounge typing, or even just physically present in the Lounge, *that* means he is working and that she should stay out. He asks her irritably if she thinks this is a rule she can handle. Crestfallen, she tells him that she can, and then he tells her to start the rule right now by getting the "fuck out."

She tells him "okay," and then, downcast, walks out of the room. Jack seems to have no regard whatsoever for her hurt feelings, and after a few moments, simply starts typing again.

There are a couple of important points to remark upon about this scene: firstly, it is a concrete instance of Jack's resentment against his wife for somehow "blocking" his

creativity. His relationship with his muse is a poor one for a writer, but it is even worse with his wife, whom he obviously holds in scathing contempt. This scene marks the first beginnings of the hostilities between the two that will begin to worsen with entropic certainty from this point in the narrative onward.

Secondly, note that the darkening of their moods—or more specifically, Jack's mood—begins precisely with the onset of the winter snow. Like the storm in Shakespeare's *King Lear* that is meant as a macrocosmic counterpart to the emotional storms in his mind, so here, the winter snows come on in exact timing with the darkening of Jack's relationship to his family. It is like a gray, heavy cloud that crosses through his mind and stays there for the rest of the winter, just as the sun's winter solstice mark—which can't be far from this point in the narrative—is the longest and darkest day of the year. It is the time of the sun's journey into the darkness of the underworld, and the beginnings of the *Walpurgisnacht* festivities that will mark the revelries of the ghosts and demons which will soon begin coming out of the woodworks of the hotel to begin their celebrations of Darkness, madness and chaos.

Ruptured Lines
(46:00 – 51:15)

It is now full on winter. The title card for this next sequence indicates that it is "Thursday" (Thor is the Germanic god of storms) and it is composed of only two shots: in the first shot, Wendy and Danny are out playing in the snow in the middle of a mild snowstorm that has covered the Overlook in a layer of milk-white powder. It is a total white-out, however, and there is almost no visibility.

In the second shot of this title card sequence, the camera *very* slowly closes in on Jack's face in an apparent catatonic trance, as he gazes out the window from the Colorado Lounge at the snowstorm. His eyes are looking upward from beneath his brows, unmoving, and the faint ghost of a smile crosses his face before the scene cuts to the next title card.

Once again, Kubrick scores the scene with Ligeti's *Lontano*—which, interestingly, means in Italian "far away," for Jack's mind is "elsewhere," and this piece also forms a bridge into the next title card, "Saturday."

What is important to note about these two scenes is that they highlight the ruptured lines of communication that are now beginning to crack, split apart and fall asunder. The

snowstorm means that the road connecting the hotel to the nearest town of Sidewinder—a town made up by Stephen King—past which the Torrances had climbed on their initial journey up the mountain is now covered with snow and rendered impassable. The Overlook Hotel has lost all possibility of physical connections to the outside world.

The shot of a catatonic Jack Torrance indicates that he is drifting away from his family and withdrawing into his own private mental space of breakdown. The state of complete stasis and mental arrest contrasts vividly with the previous scene in which he was typing away on his manuscript. Jack is beginning to recede from his own family, drifting off into inner space like the astronaut Frank Poole in *2001: A Space Odyssey* who must be cut free by Dave Bowman, while he floats off into the wilderness of outer space.

Objects, entities and people in Kubrick's narrative are now beginning to break away from each other and to recede into their own private spaces of malfunction. All lines connecting anything or anyone to anything else are slowly, one by one, being severed by hostile forces.

This becomes even more evident in the next sequence that begins with the title card "Saturday," and which is also composed of two scenes (Saturn is the god of melancholia and depression who bears a scythe which cuts, not only the wheat from the earth, but—especially in astrology--all lines connecting entities to one another).

The first sequence of "Saturday" begins with another second unit shot of the Timberline Lodge, taken, once again, from the same angle, only now it is almost completely buried in the snow. Several feet of snow create hills that have formed in the parking lot, and there is, once again, a complete whiteout.

There follows a shot of Jack in the Colorado Lounge, viewed from afar, typing away on his manuscript once again, but given the previous shot of his catatonia, we can now no longer be certain whether he is working on his book or whether he has begun to type the repetitive line "All work and no play makes Jack a dull boy" over and over again that we later find composes his manuscript, much to Wendy's horror.

Wendy is in the lobby, meanwhile, trying all the phone lines, plugging into one circuit after the next, but all channels are down, buried by the snowstorm. She walks around the reception desk in a murky winter gloom and heads into Ullman's office, where she tries the radio. With a cigarette burning (nervously) in her right hand, Wendy leans back against the table upon which the radio has been placed and contacts the US Forest Service, which receives her call. One official asks her how they are getting on "up there," and Wendy tells him they're fine but all their phone lines seem to be down. The official tells her that most winters they tend to stay down until the spring, and he also mentions to her that the storm is one of the worst they've seen in years (snow can be made out falling just outside the window above Ullman's desk in a steady downpour). The forestry official tells her that it might be a good idea for her to leave her radio on all the time for safety reasons and she tells him that she will do just that and then terminates the conversation.

This scene highlights the fact that not only is the hotel broken off into its own space due to the storm wiping out all the roads, but that the Torrances are now *electronically* isolated from the outside world, as well (with the sole exception of one line of communication to the forestry service).

Thus, the two revolutions which theoretician Paul Virilio regards as formative of Modernity—the Transport

Revolution and the Communications Revolution—both now cease to function for the Torrances.[39] The automobile that carried them up the road is now useless, and the wires carrying electronic signals to their destination points along Shannon-Weaver communication channels have ceased functioning. The Torrances, like the doomed Donner Party in the middle of the nineteenth century just when these two revolutions were getting off the ground, now find themselves *regressed* back to a state of primitive, snowbound isolation and helplessness which modern technology can do nothing to fix. They are stranded for the next three months, and the Torrances themselves, meanwhile, are drifting away from each other into their own private spaces.

One channel of communication still remains open, however, and it is a channel that is ever-widening as the snowstorm grows to epic proportions. Danny is presently shown inside his miniature dromosphere riding his tricycle through the corridors of the hotel's west wing, and as he rounds a corner—to the sounds of Krzysztof Penderecki's 1966 composition *De Natura Sonoris No. 1*--he sees the ghosts of the two Grady girls standing at the far end of the hallway clasping hands.[40] He is terrified to see them, and they invite him to come and play with them—forever and ever, as they put it—showing him visions of their bloody murder in that very same hallway by their father Charles Grady who chopped them up with an axe. Danny puts his hands over his eyes to make the vision go away and Tony tells him to remember that the images can't hurt him because they are just like pictures in a book. (Later, we will learn that both Hallorann and Tony were *wrong* about the visions and that they *can* hurt you, for the apparition of the dead woman in Room 237 will attempt to strangle Danny to death).

Danny has stumbled into one of the hotel's memory basins which store up the subtle energies of traumatic events inside the very fabric of space-time itself. Thus, the one channel that remains open while all the other technological channels are being shut down by the winter storm, is the portal that connects the living to the dead, who are now beginning to surface more and more often as the winter goes on, as though deriving strength from its negative energies. As the storm worsens and the Torrances drift ever further and further away from each other, the dead take advantage of their emotional breakdown and begin to seize on it and use it to draw strength and energy. The unhappy dead draw strength, that is to say, from the negative emotions of the living. Anger, despair and sadness are what ghosts thrive upon, since they are themselves lost spirits trapped in spatio-temporal memory ruts that replay themselves over and over again like a record that has gotten its needle stuck in the same groove.

Father and Son
(51:16 – 57:01)

The title card for this sequence reads "Monday," and it begins with a close up on a television that is playing the 1971 movie *The Summer of '42*, a story which concerns the love affair a young man has with a woman whose husband has gone away to fight in World War II. (Note that it is a tale of Eros as an *attractive* force that functions almost like gravity to *connect* people to one another, whereas the Torrances, during the winter, are drifting *away* from each other). The camera pulls back to reveal Wendy on a couch watching the movie while Danny plays with his toys on a blanket on the floor in front of the television. They are in an unspecified wing of the hotel, but there are no lights on, and the room is suffused with a pale wintry gloom as the snowstorm continues to pour down, unabated, outside.

Danny asks his mother if he can go to his room to get his fire engine but Wendy tells him that his father has only gone to bed a few hours ago (even though it is late morning and Wendy is planning on making lunch soon). Danny promises her that he will be extremely quiet—perhaps like a mouse, for he is wearing a Mickey Mouse sweater—and she gives in

to his wish but admonishes him to make sure that he really *is* quiet.

As Danny enters the family apartment, Kubrick scores the scene with the opening notes of the Adagio from Bartok's *Music for Percussion, Strings and Celesta*, which has a creeping quality to it. Danny sees his father sitting on the edge of his bed, dressed in his blue bathrobe, staring out into space and asks him whether he can go to his room to get his fire engine, but Jack tells him to come over and sit with him for a moment first. Danny goes to sit in his father's lap, who hugs him—it is the last moment of tenderness that will ever occur between the two—and his father asks Danny if he is having a good time staying at the hotel. Danny says that he is, and his father tells him he wants him to have a good time. There is a pause and then Danny tentatively asks his father if he feels bad. His father tells him he is just a little tired, and when Danny asks why he doesn't just go to sleep, Jack tells him that he has too many things to do.

Danny then asks his father if he likes the hotel, and his father tells him that he does. In fact, he says that he wishes all three of them could stay there forever and ever. Then, when Danny asks him if he would ever hurt him or his mother, Jack inquires if his mother ever told him that Jack would hurt him. Danny denies it, and his father tells him that he loves him and would never do anything to hurt him (despite having already dislocated his shoulder in a fit of rage in Vermont).

One senses, in this scene, that Jack's waking daylight personality is in full disintegration. He suffers from insomnia, nightmares and catatonic trances, and in this scene there is something deflated about him, as though he were a dead leaf that has dropped from a dying tree in winter. He is being slowly hollowed out, and his three-dimensional subjectivity

is in a kind of radioactive decay as his real personality is being replaced and overcoded by the Otherness of the hotel, which is slowly invading his consciousness and using his nervous system as an extension of its own "mind."

There is something "not convincing" about Jack's declaration of love for his child, and Danny is clearly terrified of him, sensing that he is in process of metamorphosis—like an insect inside a shell or a cocoon—into Something Else, something *not* his father.

Just as in the German philosopher Johann Gottlieb Fichte's declaration, in his 1794 work *Foundations of the Entire Science of Knowledge,* that since A = A and self-consciousness is therefore proven as self-evident—since it must posit itself as identical to itself--so Jack's situation constitutes a *reversal* of the equation, for *his* self-consciousness is no longer identical with itself, for it is becoming *not*-Jack, an entity in which A does *not* equal A.[41]

Jack's Nightmare
(57:02 – 1:02:45)

The title card for this sequence indicates that it is "Wednesday," and begins with another second unit shot of the Timberline buried, once again, in snow, but with the warm yellow incandescence of four illuminated windows burning as tiny vanilla squares through the winter's gloom.

The scene then changes to a shot of Danny playing on the carpet of the hotel's second floor with his miniature trucks and cars, when a tennis ball suddenly rolls directly towards him from out of nowhere. (It is possible that it is the same tennis ball Jack has been throwing around against the walls of the hotel). Danny stands up and looks down the empty corridor to see who might've rolled it toward him, and asks whether his mom is there. As he strides further down the hallway, he then notices that the door to Room 237 is ajar, with a key still in the lock and a red keychain dangling from it. Danny approaches the door and asks if his mother is inside the room, but receives no reply.

As Danny enters the room, the scene fades out, but Stephen King in his novel tells us exactly what happens when he goes into the room and finds the rotting body of

an old woman lying in the bathtub, a body which suddenly comes to life and reaches out to strangle him. The tennis ball is meant to remind us of the Grady Twins and their invitation to Danny to "come play with us," meaning the ghosts of the hotel in general. They want Danny, with his mediumistic abilities dead, so that they can have him play along with them on the astral side of the hotel's existence, where they can then have him all to themselves *forever*.

The scene then fades to the basement, where Wendy is busy checking the pressure gauges on the hotel's boilers and she hears the sound of Jack screaming from somewhere inside the hotel. As Jack's screams intensify, Wendy begins running up from the basement to the Colorado Lounge, where Jack has fallen asleep at his typewriter, with his head resting on the hard wood of the desk. When she finds him, he wakes up, terrified, and falls out of his chair as she asks him what's wrong. He tells her that he has just had the worst nightmare of his life, a nightmare in which he murdered both her and Danny and cut them up into little pieces. Wendy tries her best to comfort him, but she looks nervous as she helps him back up to his chair.

Part of the scene's effectiveness is that it has been scored with two compositions from Penderecki that have been carefully sutured together so that the viewer almost does not know where the first one ends and the second one begins. Immediately after the title card, "Wednesday," and following the exterior shot of the snowbound hotel, the scene is scored with Penderecki's 1974 composition, *The Dream of Jacob*[42]—indeed, most of the film's music from here onwards will be scored with various Penderecki compositions—which then melts into his 1971 composition *De Natura Sonoris II*[43] at about the time Wendy arrives at Jack's side. *The Dream of Jacob* is interesting because it refers to a dream that the

wandering patriarch Jacob had when he rested his head on a rock—Jack's head is similarly resting on a hard surface—and in the dream Jacob saw a ladder to heaven up and down which divine beings were shuttling from heaven to earth.

Now Jack, as I've pointed out, is slowly transforming into *another* entity, something which I'm calling *Not*-Jack, as he is being hollowed out and the core of his subjectivity removed as the mind of the hotel replaces and overcodes it with *its* own intentions. The parallel which Kubrick draws with Jacob's dream in both cases is that a portal between two worlds is opening up, a portal that connects the physical world with the supernatural world. In Jack's case, the portal is *inside his mind* (whereas in Jacob's case, it seems entirely exterior until one remembers that he is dreaming), wherein the Grady murders are now being inserted as a fresh set of codes for him to follow. Jack's dream is an echo of Grady's murder of his wife and two daughters, all three of whom he chopped up into pieces with an axe. That murder is now being *inserted* into Jack's mind by the hotel as a new behavioral precedent for him to follow, a precedent of reenacting the same deed all over again. For the Overlook Hotel is a place dominated by the past and the weight of its horrors, and Jack is unable to create anything new because the hotel has captured him and is using him as an extension of its own will to reenact past events endlessly in an imitation of the Eternal Return of the mythical consciousness structure in which time does not flow forward in an evolutionary progression, but simply runs round in circles, like the seasons. The same dying and reviving god is killed, cut apart and then reborn every year, just like Osiris, Dionysus, Attis or Persephone, because they are mythic codes of cyclical processes, of temporal Uroboric structures.

The hotel will not allow any new singularities to occur, for it is a place weighted down by the inertia of its past and it contains incredibly strong memory fields that suck weak-minded individuals back down into re-performing its terrible deeds. It is a place that has a mind of its own, but it lives only on the past and will allow no new futures to occur.

Jack will attempt to re-perform Grady's murder of his family, just as it is implied that Grady, in turn, might have re-performed an original murder committed in the hotel by a previous incarnation of Jack, who was the caretaker there in 1921, as the film's final image suggests. Grady later tells Jack that he has *always* been there, and so in a previous life he must've been a hotel employee from the time of its inception around 1909.

Danny then wanders into the Colorado Lounge while Wendy tells him to go away, but he simply stands there, sucking his thumb, and Wendy notices something strange about him so she runs over to him and sees that his shirt is torn and that there are bruises on his neck. Thinking of Jack's dream and remembering how he had once dislocated Danny's shoulder, Wendy accuses Jack of having tried to strangle Danny, since there is no other "logical" explanation.

The tension rises as the violin strains of Penderecki's nerve-wracking composition, *De Natura Sonoris II* (i.e. "On the Nature of Sound") plays over the soundtrack while Jack looks on helplessly, not understanding what could've happened. Penderecki's composition then forms the bridge to the next scene, in which Jack is shown walking down the hallway leading to the Gold Ballroom.

It should also be pointed out that a parallel transformation is now taking place in Danny, whose normal personality does not resurface again for the rest of the film. The trauma of the events in Room 237 has caused his alter ego, Tony,

to come forward and take possession of his mind, while Danny has receded somewhere into the abysses of his own unconscious, where he hides from the horrors that are now beginning to take place around him. He too has become a *different* entity, just like his father, an entity which I will call from henceforth "*Not*-Danny."

Jack's First Conversation with Lloyd
(1:02:46 - 1:09:50)

Penderecki's taut, high-strung violins then serve to bridge to the next scene, which features a shot of Jack walking down the hallway to the Gold Room, talking to himself and making angry gesticulations. He comes to the darkened ballroom and then flips the switch which lights it up into a display of green and gold, with luminous panels of light situated to either side of a huge mirror emanating from behind the empty bar. He strides across to the bar and seats himself on a barstool and then, head in hands, says that he would sell his soul for a glass of beer.

 The hotel, then responding to his wishes, suddenly provides him with a bartender named Lloyd and a full case of liquor. Jack recognizes him and says, "Hi, Lloyd!" And when Lloyd asks him what he would like to drink, Jack tells him that he has two twenties and two tens sitting in his wallet and that he thought they'd be there until next April. He asks Lloyd to serve him a bottle of bourbon, a glass and some ice, but when he checks his wallet and finds it empty, he asks Lloyd how good his credit is in this establishment. Lloyd then informs him that his credit is "fine."

Jack tells Lloyd that he "always liked him" and thought he was the best goddamned bartender from Portland, Oregon to Portland, Maine. Lloyd thanks him for saying so.

When Lloyd asks him how things are going, Jack tells him that it's nothing he can't handle, just a problem with the "old sperm bank upstairs." Lloyd sympathizes with him.

As Jack drinks his bourbon he tells Lloyd that he never laid a hand on Danny and that he loves him and would do absolutely anything for him. But Wendy, he says, will never let him forget what happened on the day when he came home and accidentally dislocated Danny's shoulder by applying just a *bit* too much pressure than was necessary. (Much of the dialogue of this scene is lifted whole from the book).

Now, regarding the ontological status of this scene—in other words, whether it is a conversation taking place entirely within Jack's head, or whether he is dialoguing with a real ghost—it should be regarded as a kind of Derridean gray zone or "undecidable" in which it contains elements from both the Real and the Imaginary orders.[44]

The hotel has a mind of its own, and is capable of responding to the wishes of those who are willing to shed more human blood on its behalf, since it lives on blood, like the Aztec gods. It knows what Jack's wishes are, and it senses that he can be manipulated into reperforming the Eternal Return of Grady's murder of his family.

But in order to do this, it must first establish a dialogue with him.

So, if the conversation with an imaginary bartender is taking place inside Jack's mind, the hotel nevertheless senses his wishes and uses his weakness for alcohol as a lure to begin the process of "exteriorization" of what is in his head. Anything Jack imagines, the hotel can replicate for him as

a three-dimensional simulacrum—as long as it serves the hotel's interests as a kind of hyper-entity--and this scene establishes the beginnings of the Faustian bargain that it makes with him. Jack is willing to sell his soul for alcohol and the hotel knows this. It therefore begins to respond to his wishes because it knows that he will be taken into its folds and overcoded by its desire for blood. The hotel *wants* Jack to murder his family because it thrives on blood, chaos and mayhem. So it uses the phantom bartender Lloyd as its initial means of communicating with him.

In the previous sequence, it invaded his mind in the form of a nightmare. Now it is beginning to exteriorize his desires in the form of a simulacrum that responds to his wishes so that it can then manipulate him into an act of carnage.

For now, the scene may be regarded as taking place "inside" Jack's head. But the point is that the boundaries between what is inside his mind and the reality of what is outside it are beginning to blur as the hotel hollows him out and begins to transform him into *Not*-Jack, an entity that functions as a sort of conduit through which the hotel's phantoms are enabled to use his energies to exteriorize themselves into three-dimensional reality.

First, though, it must make a Faustian bargain with him, since it already senses his pre-existent aggressions toward Wendy and Danny. *Then* it will be able to use him to reperform Grady's murder for its own entertainment.

When Wendy comes running up the hallway with a baseball bat in her hands, she enters the Gold Room and the viewer is shown Jack sitting by himself. Nevertheless, the boundary that separates the contents of his mind from the memory phantoms of the hotel is beginning to dissolve and it does not necessarily mean that the conversation was completely imaginary.

Wendy tells him that a crazy woman in one of the hotel's rooms—whom we *know* to be real, since she tried to strangle Danny—has been hiding out in the hotel. Jack asks her if she is out of her fucking mind, and he sounds genuinely drunk when he does so.

But nevertheless, he asks her to tell him which room it was so that he can then go and investigate.

Room 237
(1:09:51 – 1:16:12)

This sequence begins with a shot of Hallorann watching the local news inside the Miami apartment in which he is spending the winter. The newscaster mentions that Miami is suffering from a heat wave, but the Rockies are buried in snow. As the camera pulls back, Hallorann is resting on his bed, but after a moment his eyes widen as though he were going into a trance state and seeing something terrible. A shot then follows of Danny in his bedroom using his telepathic powers to contact Hallorann. As Stephen King's novel tells us, Danny is literally *screaming* at Hallorann through his mind to come back to the Overlook and help them, for something terrible is about to happen.

Next comes the shot of Jack pushing open the door to Room 237 while Penderecki's *Dream of Jacob* plays once again on the soundtrack but this time it is synchronized with the sound of a beating heart. The room is decorated in a sickly purplish Art Deco style, but it is in pristine condition and looks scarcely disturbed. The door to the bathroom is closed, and the viewer sees Jack's hand push it open to reveal a brightly lit lavatory painted in green with a yellow

stripe adorning the top of the wall. (The green color not only alludes back to the greenish hue that was emanating from behind the closed shower curtains in the bathroom in Boulder where Danny had his first vision, but it gives to the scene a kind of aquatic effect, as though it were submerged underwater).

The shower curtain to the bathtub has been drawn partly shut and there is a figure which can be glimpsed on the other side of it. A shot of Jack, looking apprehensively at the bathtub then follows, while Kubrick reveals that the figure pulling back the bathtub curtain is a beautiful young woman, completely naked, who rises up and steps forth gracefully out of the bathwater like Amaury Duval's 1862 *Birth of Venus*.

Jack's expression slowly changes to a lascivious smile as the woman approaches and comes to face him. She reaches out to him with both arms to embrace him and he begins to kiss her. During the kiss, however, he opens his eyes to see that the reflection in the mirror that is behind the woman does not match the beautiful woman he thought he had been getting, but is instead not merely an old hag, but the dead and rotting corpse of an old woman. Kubrick inserts a shot of the dead woman in the bathtub just as Danny found her, rising up slowly and getting ready to strangle him.

As Jack steps back in horror, the old woman starts cackling hideously at him, slowly walking toward him with her arms in front of her like a zombie. Jack backs out of the apartment in terror, slamming the door shut behind him as he flees down the hallway.

Thus, both father and son have had a terrifying encounter with the woman in Room 237: whereas, when Danny found her in the bathtub, she reached out to strangle him in an attempt to murder him, Jack was lured by the promise of an erotic encounter that turned into a necrophiliac nightmare of embracing a purple and rotting green corpse.

The woman is, on the one hand, Jack's muse, which is strangling everything he creates, including his child, but also his creativity as a blocked writer. She is associated, like all the Muses were, with water—specifically, the Pierian Springs—which in the present instance happens to be a bathtub.[45] But on the other hand, the woman is yet another lure that the hotel sends forth to capture Jack and begin its process of overcoding him into a servant willing to do the hotel's bidding in murdering Danny so that it can have him all to itself.

First it has conjured forth Lloyd the bartender and used the lure of Jack's weakness for alcohol as bait to catch him

on the end of the fishing line, as it were, and now it uses the image of an ideal young woman beckoning to him with erotic promise as yet another lure. Both figures are simultaneously *inside* Jack's mind and yet exteriorized outside of it, since the hotel can exteriorize anything the mind thinks (especially its deep subconscious fears). In Jungian terminology, Lloyd would be the figure of the Shadow, who appeals to Jack's weakness for alcohol and makes a kind of Faustian bargain with him, while the young woman would correspond to his anima, whispering secrets into his ear that promise new life (and death) possibilities.

In another sense, the woman in Room 237 corresponds to the Grady twins, for as I have already remarked, they are a variation of the ancient two-headed goddess which later separated in human cultural history in the Middle East into the twin sisters known as Inanna, the beautiful mistress of love and sex and her sister Ereshkigal, mistress of the dead in the underworld. The image of the putrescent woman in the mirror corresponds to Ereshkigal, for there is a doubling motif that runs all through the film in which mirrors and mirror images transform characters "through the looking glass" into parallel, but asymmetric, selves. We have already seen Jack awakening and looking at himself while Wendy was serving him breakfast in bed, sticking his tongue out in the mirror, and suggesting a mask-like being such as was common amongst Native American masks of the Pacific Northwest, in which figures sticking out tongues had shamanic associations. Danny was looking in the mirror in Boulder at *his* alter ego, Tony, another personality that lives inside him and takes over whenever circumstances become too traumatic for Danny's waking daylight personality to bear.

The hotel is luring Jack in, slowly capturing him by appealing to his weaknesses and transforming him into the entity I have called *Not*-Jack. Not-Jack is the parallel self of Jack Torrance, just as Tony is the parallel self of his son Danny. But the purpose of the hotel's transformation of Jack into Not-Jack is to get him to murder his family so that it can capture their spirits and trap them inside the Eternal Playhouse of its labyrinth. The more souls it captures, the stronger the hotel becomes, and the more blood it lives upon, the more difficult becomes any attempt at escaping from its labyrinth.

Jack's Report
(1:16:13 – 1:21:26)

Hallorann is now shown in his shadowy, Venetian-striped Miami apartment attempting to dial a phone call directly to the Overlook Hotel, but he gets a message that tells him that the call cannot be completed as dialed. (As remarked earlier, all lines of *physical* and *electronic* communication that connect the hotel to the outside world have been ruptured: roads are snowed out, and phone lines are down. However, as the previous scene with Danny sending a telepathic message to Hallorann has shown, and also Jack's encounter with both Lloyd and the woman in Room 237, there are *supernatural* lines of communication that are open, which allow Jack to communicate with the dead, and Danny to send telepathic distress signals to the living).

Wendy is then shown nervously awaiting Jack's return, and when she hears a knock at the door, she goes to open it and asks Jack whether or not he found out anything in Room 237. Jack lies and tells her that he found "nothing at all," "not one goddamned thing." (At this point, he is not quite certain whether he is losing his mind and imagining these entities, or whether they are actually real, and Kubrick, thus

far, deliberately keeps the matter ontologically "undecidable." He wants the viewer to entertain the possibility that thus far all of the supernatural entities which Jack has encountered are delusions of Jack's brain. There still exists the possibility that he *may* be slowly going mad).

When Jack inquires how Danny is doing, Wendy tells him he is sleeping and Jack says, "Good," then closes the door to his bedroom (but in fact, Danny is wide awake and having terrible visions of the nightmarish circumstances to come. He has gone into a sort of shamanic trance state in which he can send Hallorann telepathic messages and also listen in on his mother's and father's conversation).

Wendy, in tears, asks Jack if he is sure he went into the right room and that possibly Danny made a mistake, but Jack tells her that he must've gone into that room since the door was open and the lights were on. They sit down on the bed and Wendy then asks about the bruises on Danny's neck, but Jack tells her he thinks he did that to himself and that it wouldn't be much different from the episode that occurred in Boulder before they left. When Wendy tells him that it is impossible that Danny could have given those bruises to himself, Jack counters by saying that once Danny's version of what happened is ruled out, then there is simply no other explanation.

There follows a shot of Danny lying awake in bed, terrified as he listens to his parents' conversation and has a vision in his head of the word "Redrum" scrawled in red lipstick on a door. Note that what he is seeing is yet another mirror image, for "Redrum" is simply "murder" spelled backwards. In other words, the murders which give life to the hotel are translated into the "red rum" of its lifeblood, and indeed, there follows once more the vision of blood pouring from the elevator that Danny had seen in Boulder.

Wendy tells Jack that, whatever the explanation for the bruises on Danny's neck, they have to get Danny out of the hotel. When Jack says, "You mean, just leave the hotel?" and Wendy assents, he becomes suddenly furious at the thought of being separated from the organism of the hotel with which his nervous system is slowly becoming entangled. Leaving the hotel is now the *last* thing that Jack wants to do, and he tells Wendy that it is "fucking typical" of her to create a problem right when he has the chance to accomplish something great with his writing. He stands up and asks her aggressively if she would prefer that he return to Boulder and shovel out driveways or work at a car wash. Then he points at her with his index finger and tells her he has already let her fuck up his life thus far and that he is *not* going to allow her to do it again.

As he storms out of the apartment, Jack glares menacingly at the camera, slams open the front door and walks out. Wendy, left behind on the bed and in tears, has no idea what to do.

Jack is then shown walking down the kitchen hallway, and in a tantrum, starts throwing piles of utensils around. It is a deliberate echo of the previous scene in which, after Wendy had accused him of strangling Danny, he had gone down the hallway to the Gold Ball Room gesticulating angrily. He will soon enter the Gold Ball Room once more. It is important to note that everything in *The Shining* runs round in circles, for everything—and everyone--is caught by the "repetition compulsion" that is characteristic of souls trapped in the underworld (i.e. Tantalus forever reaching out for the fruit that he can never quite grasp, or Sisyphus rolling the stone uphill that is condemned to roll back down hill over and over again for eternity).

Now, as he rounds the corridor leading into the hotel lobby, he can hear music playing, ostensibly from the 1920s (the actual song is "Masquerade," recorded by Jack Hylton and his Orchestra in 1932. Though it is meant to *evoke* the 1920s, it is the lyrics of this song, which are rather creepy, that must have appealed to Kubrick: "My only friend was solitude / And only darkness seemed to care / So I forged this dreadful mask / That I am cursed to wear."[46] This links back to the mask that Jack's face resembled when he was looking at himself in the mirror and sticking his tongue out. In other words, he is gradually in process of being "flattened" out and depersonalized to the level of a masked supernatural being). The hotel lobby, as he enters it, is decorated with festive balloons and streamers as though he had just walked into the middle of a New Year's Eve party.

The *Walpurgisnacht*, in which—in this case, anyway—the dead celebrate the triumph of wintry darkness and the opening up of the underworld during the winter solstice, is now underway. Normally, the *Walpurgisnacht*, or "Witches' Sabbath" takes place in the springtime and is meant drive away the evil spirits that have escaped from the underworld during the winter, whereas in *The Shining* the dead are trapped in the Eternal Return of a perpetual celebration of Darkness that takes place every winter since the hotel was built. The Greek equivalent to the German *Walpurgisnacht* was the so-called Anthesteria, a festival held in February over three days, in which the dead were imagined to roam freely and in which libations were made to them in order to make them go away with the ending of the winter and the onset of spring. The third day of the festival was known as *Chytroi* (i.e. "feast of pots") and was the day on which the festival of the dead took place. Offerings were made to them in the form of cooked pulse and especially to Hermes Chthonios,

who was bidden to take the dead and lead them back down to the underworld.[47]

In the case of *The Shining*, Jack has stumbled into a time warp, for it is a party that is taking place in the 1920s and he will be present at the very same party that Kubrick pictures him as historically present at in the film's final image of a black and white photograph specifically taken at this party (although that party is a July 4th celebration, since the hotel would always have been closed in the winter. Nonetheless, the idea remains that it is an *eternal* and *unending* party). The implication is that Jack was alive in a previous incarnation and was present at these very same festivities in the year 1921. Since all the present revelers, however, are ghosts, the 1921 party has turned into an *eternal* party that has never ended, and at which Jack was present then and is re-present now.[48]

Charles Delbert Grady
(1:21:27 – 1:31:41)

This sequence begins, once again, with Dick Hallorann inside his darkened Miami apartment attempting to contact the Overlook Hotel via the Forestry Service. He tells the man who answers that he is the head chef at the hotel and that he is worried about the family that is up there with a small child and would like to see if the forestry official could contact the hotel on its radio. The official agrees and tells Hallorann to call him back in twenty minutes.

Jack, meanwhile, is shown walking down the hallway leading to the Gold Room once again—for everything repeats in *The Shining*—only this time the song "Midnight, the Stars and You" is playing (which Kubrick believed, mistakenly, to have been a song popular in the 1920s, since it was actually recorded in 1934)--and there is a party inside the Gold Room in which everyone is dressed in 1920s fashion.

The fact that liquor is being served in a 1920s hotel in America is difficult to explain given that Prohibition was in effect from 1920-1933, but at any rate, it is clear that Jack has stumbled upon a temporal sinkhole and is very possibly

attending *the same* July 4th party that is dated 1921 on the photograph shown at the film's end.

Jack strides (once again) to the bar, where he seats himself on a bar stool and says "hello" to Lloyd and also that he has been away, but now he's back. When Lloyd asks him what he'd like to drink, Jack tells him "the hair of the dog that bit me" and Lloyd interprets this to mean bourbon on the rocks, to which Jack accedes. When Lloyd pours him the drink, Jack opens his wallet, but this time it is not empty and he offers a twenty dollar bill to Lloyd, who then refuses to take it, telling Jack that his money is no good there and that it is on orders from the house.

At almost this exact moment, the lyrics that are playing on the song "Midnight, the Stars and You," as sung by Al Bowlly go: "Midnight brought us sweet romance / I know all my whole life through / I'll be remembering you / whatever else I do."[49] Jack, in other words, is *already* a memory engram trapped into the behavioral actions of Eternal Return in the hotel's resonant field of past events. The hotel is *remembering* him from his earlier incarnation there in the 1920s.

Jack then tells Lloyd that he is the kind of man who likes to know who's buying their drinks for him, but Lloyd tells him that it is not a matter than need concern him right now, at least not at this point. Jack tells Lloyd "anything you say, Lloyd" and then picks up his drink and saunters away. He is dancing to the music when a waiter comes approaching him from out of nowhere and, in order to avoid a woman wearing a gold dress on her way to the bathroom collides with Jack and spills two drinks of advocaat on him. The waiter apologizes and tells him he'd better come with him to the restroom to wash the drink out, as advocaat tends to stain.

Jack and the waiter—who is, of course, Charles Delbert Grady—then enter the men's room, the walls of which are painted a striking blood-red, perhaps as a foreshadowing of the blood which the hotel *wants* Jack to spill in murdering his wife and son.

As Grady is cleaning his jacket, Jack asks him what they call him around here, and when he replies, "Grady, sir. Delbert Grady," Jack recognizes the name. Jack then asks him if he hasn't seen Grady somewhere before? Grady denies it, and when Jack asks him whether he was once the caretaker at the hotel, Grady denies that, too. When Jack then asks him if he's married, Grady replies that he has a wife and two daughters, and when Jack asks where they are, Grady says they're running about somewhere.

Jack then insists that Grady *was* the caretaker at the hotel because he recognizes his picture from newspaper articles (and since we have already seen a scrapbook open beside Jack's typewriter with newspaper articles pasted inside of it, there is a possible hint here that the book Jack was working on concerned, or was inspired by, the Grady murders). Jack then goes on to tell Grady that he *knows* Grady chopped his wife and daughters into little pieces and then blew his own brains out.

Grady pauses heavily for a moment and then he tells Jack that he begs to differ with him on this matter, but that *Jack* is the caretaker of the Overlook Hotel, and furthermore that he has *always* been the caretaker of the hotel and that Grady would know because Grady himself has *always* been there. Grady then asks him whether Jack was aware that his son was attempting to bring an outside party into this situation, a "nigger cook" as he calls him. When Jack asks how, Grady tells him that his son has a very great talent, and that Jack is not apparently aware of how great his talent is and that his

son is attempting to use that talent against his father's will. Jack's eyebrows then lower and he tells Grady that he agrees that Danny is a very willful boy. Grady insists that Danny is a very "naughty" boy and then Jack smiles and tells Grady that the real problem is Danny's mother, who "interferes."

Then Grady suggests that perhaps his wife and son need a good "talking-to," perhaps, Grady then qualifies, even something a "bit more." Grady says that his daughters didn't care for the Overlook Hotel at first, either, and that one of them stole a pack of matches and tried to burn it down. But Grady "corrected" her, as he puts it. Then he says that when his wife tried to prevent him from doing his duty, he was forced to correct her, too.

Thus, the scene ends with Grady planting the idea in Jack's mind of killing his wife and son, although he has already had a nightmare that was a sort of resonant echo of Grady's deed. Grady, when he murdered his family in 1970, did so as part of the hotel's immune system, for the deed was prompted by the threat of his daughters burning down the hotel. The implication, though, that Grady, too, like Jack, has *always* been there suggests that he too may have been reperforming some terrible deed which he had perhaps done once before at the hotel in another lifetime.

The hotel's immune system, via Grady, has identified Hallorann as an antigenic threat to its purposes: it wants Danny to "come play" with the revelers forever, and it can only do that if it can manipulate Jack into murdering his wife and son. Jack is now becoming an appendage, an extension of the will of the hotel and its temporal sinkholes which constantly repeat past events. It wants Jack to reperform Grady's murder of his family and it has been slowly "hollowing" him out as a Subject in order to do this. Jack is becoming depersonalized and *losing* his

three-dimensional subjectivity and the freedom of will that accompanies it. The supernatural forces inside the hotel are beginning to wear him as a mask and to absorb him into its temporal repetitions. He is becoming an archetype, forever condemned, as the song "Masquerade" that was playing in the hotel lobby puts it, to wear a mask.

Masks constitute a flattening out of the waking daylight personality and of an absorbtion of the individual into a transpersonal world of collective instincts and ancient desires. It is the species which begins to dominate and take precedence over one's own individuality as it does so. An individual subject, in wearing a mask, is no longer a human singularity, but a living incarnation of a perpetual cycle that returns back again to the same point every time, as a "hell of the same."

And as the mirror in the red men's restroom seems to suggest, Jack in conversing with Grady is actually conversing with a mirror image of himself; in other words, yet another incarnation of the exact same archetype. Just as the mirror in Room 237 showed him the rotten and putrescent state of his own decaying Muse and the consequent loss of his creative abilities—for to create something new would constitute a singularity that is a violation of the hotel's rules as a living temporal sinkhole that sucks every event backwards into the past—so the mirror in this scene suggests that Charles Delbert Grady is his own alter ego.

Everything, as I have stated repeatedly, occurs in doubles in *The Shining*—even Wendy has her prototype in the form of Grady's dead wife—with the possible exception of Danny, whose telepathic abilities make him a kind of singularity that the hotel is jealous of and wants for itself. Tony *is* Danny's double, but Tony is also a personification of those very abilities themselves—i.e. the power to foresee *future*

events, rather than simply remaining stuck in the repetition of past events—that the mind of the hotel is anxious about, for it wants to absorb those very abilities by having Danny murdered so that his astral spirit can be stored in the hotel's memory banks *forever.*

Halloran on His Way
(1:31:42 – 1:41:18)

Wendy is now shown in conversation with herself inside the family's apartment, smoking a cigarette as she reasons out an escape plan. She reminds herself that they have the snowcat and that they could possibly make it down the mountainside if the weather breaks, and that she could notify the forestry service to look for them in case they didn't make it. If Jack doesn't want to go with them, she thinks, then she and Danny will just have to go alone.

Her thoughts are interrupted by Danny's voice coming from his bedroom, saying the word "redrum" over and over again in Tony's creepy voice. When Wendy opens the door to his bedroom and runs in—spooky voices and a beating heart are playing on the soundtrack—his voice gets louder for a moment and then stops. When she sits on the bed and asks him what's wrong, he turns mechanically to look at her and tells her in the voice of Tony that "Danny is not here, Mrs. Torrance." She insists that he has just had a bad dream and that he needs to wake up, but Tony tells her that Danny *can't* wake up. Just as Jack is becoming another entity known as Not-Jack, so too his son Danny, terrified by this new entity his father has become, has himself become Not-Danny.

Jack is then shown calmly striding down the brightly lit corridor of the hotel lobby, where the voice of a forestry official can be heard coming from the radio in Ullman's office trying to contact them. Jack goes into the office, opens the lid to the radio, and pulls out three transistors that render it completely inutile. Note that this scene is another of the film's mirror images, for it is in striking contrast with Jack's first visit to Ullman's office at the start of the film, in which he had been interviewing for the role of caretaker of the hotel. Now, in a certain sense, his nervous system has become fused together with that of the hotel's, and all outside threats are being eliminated one by one in preparation for a re-performance of the very Grady murders that Ullman had told him about in that same office.

As the beating heart continues on the soundtrack, Kubrick returns the viewer to Hallorann's apartment where he is trying, one last time, to contact the forestry officials. The man who answers, however, tells him that he has had no success in contacting the Torrances and Hallorann now realizes that he has no choice but to fly up to the hotel himself.

Next comes a title card that reads "8 am": Note that, in the sequence of the title cards, months have contracted to days of the week which have now contracted to hours, for it is the narrative's last day and all subsequent events will take place before the day is out. *Every* hour now counts from henceforth and will make the difference between life and death for the film's protagonists. Kubrick then shows Hallorann flying onboard a Continental Airlines jet toward the Rockies. Inside the flight, Hallorann asks a stewardess what time they are due to arrive in Denver, and she tells him 8:20 am.

The scene then fades to a shot of Jack typing in the Colorado Lounge. By now, he is most certainly typing the same sentence, "All work and no play makes Jack a dull boy" over and over again, for page after page. His actions have become completely circular and repetitious, as the Overlook has invaded and programmed him for *repeating* actions, rather than initiating any new ones. The Overlook is a place where the past weighs so heavily that things only ever *re-happen* there time and time again, even down to the tiniest micro-details like someone retyping the same sentence obsessively. It will tolerate no new behavior patterns or events as singularities, which is why it perceives Hallorann's approach as a major threat. If Hallorann arrives in time to prevent Jack's murder of his family, then the circle of Eternal Return will be broken and some of the hotel's power will then be lost. That will then mean that *other* people will be able to escape from its circularities and will not be as easy for the hotel to capture once the precedent is set for cutting the mythic circle of the snake biting its own tail. At the Overlook Hotel, the mental consciousness structure that began with the syllogistic reasoning of the Greeks and which cut into all the circularities of the prior dominance of the mythical consciousness structure with the new organon of logical reasoning, is disrupted and dismantled by the resurgence of both the mythical *and* the much more archaic magical consciousness structures which prevail there.[50] Singularities, *Ereignis* events and new ideas are swamped by the magical powers of the Native American sign regime whose ghostly energies are emanating from its tribal burial ground as the unhappy spirits take delight in dismantling the white man's cognitive triumphs of mechanization taking command.[51]

Hallorann, at any and all costs, must *not* be allowed to

enter the hotel and stop the murders from taking place.

A scene is then shown of Hallorann's plane landing at Stapleton International Airport in the snow and ice (since demolished and rebuilt as Denver International Airport).

The scene now shifts once again—and notice that they are becoming shorter and shorter as the tension mounts—this time to a garage located up in the mountains known as Durkin's Auto Supply. The red snowcat which Hallorann will use is seen sitting outside to the right of the garage. Larry Durkin is himself shown talking to a customer in a car parked in front of his garage for a moment before going inside the building. Upon entering, he stamps the snow off his feet and then walks over to the main desk to answer the phone. It is, of course, Hallorann, whom Larry is surprised to hear from, and asks what the weather is like down in Florida. But Hallorann tells him that he is not in Florida at all but at Stapleton Airport and so Larry asks what he's doing there. Hallorann explains that Ullman has called him and told him to go up to the Overlook Hotel, since the winter caretakers have turned out to be completely "unreliable assholes," and he has to find out if they need to be replaced. Larry tells him the weather is bad and that all the roads are snowed out, and Hallorann then requests that he will need a snowcat to get up there. Larry asks him how long it will take him to make the drive, and Hallorann says he will rent a car and that it will take him about five hours. Larry assures him he'll get him set up when he arrives.

There then follows a shot of Hallorann's dangerous drive up into the mountains along icy roads. The announcer on the radio informs the public that the weather is terrible and that all tires will require snowchains for anyone travelling the roads. To highlight the danger Hallorann is in, he passes an overturned semi that has crushed a red VW Volkswagen

in an accident on the icy road. The announcer also says that only a few flights are now landing at Stapleton International Airport and that in about an hour it will be closed altogether. Hallorann has made it just in time.

The scene then shifts to Wendy and Danny watching Road Runner cartoons inside their apartment. (Note that the music goes, "Road Runner, if he catches you, you're through," referring to the Coyote. Later, as Jack is hacking down the bathroom door, he calls Wendy and Danny "little pigs" from the story of "The Three Little Pigs," meaning that he has cast himself in the role of the "Big Bad Wolf"). Wendy looks worried and she is chain-smoking, then glances at her watch and puts out her cigarette. She then tells Danny—who is clearly still Tony by the furrowed eyebrows on his face—that she is just going to talk to his father for a few minutes and that she wants him to stay where he is and continue watching television until she returns. She tells him that she will lock the door. Tony says to her, talking with his left index finger, "Yes, Mrs. Torrance," and then she creeps across the room and grabs the wooden baseball bat from a chair, making sure that Danny does not notice what she is doing as she exits the apartment.

It is time for her and Jack to "play" their game of bat and ball.

Confrontation
(1:41:19 – 1:53:18)

This scene is a long one that begins with Wendy nervously entering the Colorado Lounge looking for Jack, armed with a baseball bat. Kubrick scores the scene with another Penderecki composition, this one entitled *Polymorphia*, composed in 1961 for 48 stringed instruments.[52] The title essentially refers to Penderecki's idea of a composition built around "the same sound in many forms," and indeed, as Wendy discovers Jack's manuscript and flips through its hundreds of pages to find the same sentence, "All work and no play makes Jack a dull boy," reiterated over and over again, the nervous plucking of the strings in Penderecki's composition perfectly echoes his inspiration for a piece in which the same sound is reiterated in many forms, just as in Jack's manuscript, the same sentence is reiterated in different styles, different paragraphs, etc.

Jack's mind, as the Overlook has dismantled and rebuilt it to suit its own specifications, is essentially a needle that has gotten stuck in the same vinyl groove replaying the same thought endlessly. He is now incapable of thinking beyond the idea of obsessive reiteration of the same thought, just as

he is about to re-perform the Grady murders.

He has made the mistake, though, of showing up unarmed, and when he appears as if out of nowhere, he startles Wendy by asking her how she likes his manuscript. She screams and holds up the baseball bat defensively, as he walks forward with a sly grin on his face and asks her what she's doing down here. She stammers out that she just wants to talk to him, and he tells her "ok, let's talk," as he flips playfully through the pages of his manuscript. He then asks her what she wants to talk about.

She claims that she can't remember, and he suggests that maybe it was about Danny, while the scene cuts to a shot of Danny back upstairs in the family apartment in another trance state in which he can telepathically overhear their conversation. As Danny's mind fills with visions of blood—yet again—flowing out of the elevator and the image of the word "Redrum" written in lipstick on a door, Jack suggests that he thinks they should discuss Danny and what should be done about him.

As he slowly—and ever more and more aggressively—approaches her, Wendy continues throughout the whole scene walking backward, and Jack asks her what *should* they do about Danny, but she claims she doesn't know. Jack, however, still grinning to himself—for he has already long since become Not-Jack—says he doesn't think that that's true and that he thinks she has some very definite ideas about what they should do about Danny. Jack would like to know what they are.

Tearfully, Wendy says that she thinks maybe he ought to be taken to a doctor, and then Jack mimics her in a caricature that mirrors her own sentence back at her. His personality at this point is in complete disintegration. He asks her, comically, when does she think that *maybe* he should be

taken to a doctor and when she replies that it should be done as soon as possible, he mocks that sentence back at her, too.

The presence of mirrors throughout Kubrick's film now begins to internalize within the dialogue of the characters themselves as Jack mirrors back in caricature many of Wendy's terrified sentences.

Jack insists that she believes Danny's health is at stake, to which she agrees, still walking backward defensively as he approaches her, and that she is concerned about him, to which Wendy also agrees, backing toward the main staircase now. Jack then asks whether she is concerned at all about *him*?

She tells him that she is, of course, concerned about him, and once again he mirrors this sentence back at her in a caricatured fashion.

He asks her if she's ever had any thought about *his* responsibilities, growing increasingly angrier and angrier as she asks him, still crying and walking backwards, what he's talking about. Then, in circular fashion, he repeats the sentence two more times, asking her if it has ever occurred to her that he has responsibilities to his employer and that he has agreed to look after the Overlook Hotel until the first of May. Once again, he repeats the same thought in "polymorphic" form, asking her if it has ever occurred to her that he has accepted that responsibility and signed a contract in which he has agreed to fulfill those duties?

He asks her if she has the slightest idea of what a moral and ethical principal means, as she slowly walks backwards, step by step up the grand staircase. (And here he has made his second mistake, allowing her to have the higher ground over him in a violent confrontation that gives her the advantage with a weapon).

Again and again, in "polymorphic" fashion, he keeps asking her if it has ever occurred to her what would happen to him if he failed to live up to his responsibilities.

In self-defense now, and beginning to sense the impending violence, Wendy begins to swing the bat in short, sharp arcs at him, telling him to stay away from her. She tells him that she just wants to go back to her room and that she is confused and wants to think things over, but he tells her, as they go up the second half of the grand staircase, that she has had her whole *fucking life* to think things over, and asks her what good a few more minutes would do her now?

As they are backing toward the top of the stairs, Jack begins making menacing gestures at her, and she tells him over and over again to stay away from her (all actions and words, by this point, are moving in tighter and tighter circles of repetition). He tells her, mockingly, that he isn't going to hurt her at all: he just plans to bash her fucking brains in.

He laughs comically at his own wit, and she begins swinging the bat more aggressively as he tells her straightforwardly to stop swinging it at him. (The bat is perhaps a reminder, like the tennis ball that rolled toward Danny in the hallway near Room 237, that the ghosts of the hotel, just like the Grady girls told him, want the Torrances to come and "play" with them; *forever, and ever*, as they put it.) Jack tells her once again to put the bat down and then sticks out his tongue, just as he had stuck it out before in one of the film's early scenes when he was first waking up and she was serving him breakfast, thus alluding to the motif of the tribal mask again. He has been transformed by this point in the movie into a scary tribal monster possessed by a kind of creature which the Native Americans of the Plains called a "Wendigo," and which lives by eating human flesh.[53] (Once again, the film's mirror motif is at work, in this case echoing

Wendy's own name).

Jack continues to taunt her, then suddenly reaches out to try and grab the bat from her but she manages to hit him on the knuckles and he pulls his hand back, yelling "Ow, goddamn it!" She then hits him, very hard, over the head with the bat, and he goes tumbling backwards down the stairs, knocked unconscious.

The next scene shows her dragging Jack across the floor of the kitchen to the dry goods storage larder. He is still unconscious, but waking up very slowly. As though to remind the viewer that Hallorann is still on the way, the title "Chef's Office" can be read on the wall just over her head. She struggles with the lock for a moment, then realizes that she has to take the pin out first, opens the storage door and drags him by his feet inside of it. He wakes up, but his mind is blurry and he is confused about what is going on, but by the time he reaches out to grab her, she has already shut the door on him. He tries to stand, but he has injured his foot in the fall, and he knocks into a stack of boxes of Rice Krispies that come tumbling down all around him.

By the time Jack comes to and realizes that she has gotten the better of him, it is too late: the door is closed and locked. He yells at her from inside, and she turns and grabs the nearest weapon, a knife this time, while she collapses to the floor, listening to his pleas to let him out. He tries to play on her sympathies and tells her that she has hurt his head badly and that he needs a doctor, but she replies that once she and Danny take the snowcat down to Sidewinder, she will return with a doctor.

Kubrick shoots Jack from below looking upwards as he grins maniacally and tells Wendy that she has a *big* surprise coming to her and that she isn't going *anywhere*. He tells her to go check out the radio and the snowcat and then she'll

understand what he means. He keeps yelling, "Go check it out!" in a series of "polymorphic" variations as he cackles at the prospect of having trapped Wendy and Danny from escaping the hotel.

Trapped
(1:53:19 – 1:57:48)

Wendy is now shown running out through the lobby doors and into the blue-white snow drifts of the late afternoon. She bounds across the snow to the garage, where she finds that Jack has indeed sabotaged the snowcat's engine, thus trapping her and Danny at the hotel.

The next title card now reads "4 pm" and is followed by a distant shot of the Timberline Lodge buried in snow, with just a few tiny yellow lights that make the hotel look like a miniature Christmas town village ornament.

But Jack, too, is trapped: the next shot shows him to be asleep inside the dry goods storage room when a knock comes upon the door, awakening him. The knock comes a second time, but Jack has difficulty making it to his feet. His head still aches and his ankle hurts. He asks if it is Wendy at the storage door, but the voice that comes back, surprisingly, says to him that "it's Grady. Delbert Grady."

Jack limps over to the door and tells Grady "hello."

But Grady does not sound pleased. He points out that Jack has failed to take care of the business they had discussed. Jack tells him that there's no need to rub it in,

and that he will deal with that situation the moment he gets out of the storage room. (On the shelf behind him, we note the presence of Calumet baking powder with an image in silhouette of a Native American chieftain, as though to reinforce the film's Native American sign regime).

Grady, however, expresses doubts about Jack's ability to deal with the situation. Grady tells him that both he and "others" at the hotel have come to believe that Jack's heart is not in this deed and that he hasn't the belly for it.

Jack asks for one more chance to prove that he is up to it, and that is *all* he asks.

But Grady points out that his wife appears to be stronger than either of them had imagined, somewhat more, as he puts it, "resourceful." He says that she seems to have gotten the better of him.

But Jack insists that that is the case only for the moment.

Grady tells him that he is afraid that Jack will have to deal then with this matter in the harshest possible way.

Jack replies that there is nothing he looks forward to with greater pleasure.

Grady asks him if he will give his word on that, and Jack says that he will give him his word.

There follows the sound of Grady pulling the pin out of the door to release Jack.

This is a crucial moment in the film because, as Stanley Kubrick himself pointed out in an interview with Michel Ciment that "it's not until Grady…slides open the bolt of the larder door, allowing Jack to escape, that you are left with no other explanation but the supernatural."[54]

Thus, it is at this moment that Kubrick confirms the ontological reality of the ghosts in the film and that the Overlook is, in fact, a kind of living organism that has been communicating with both Jack and Danny all along.

Jack is not merely imagining these entities, for they are real and they want him to re-perform Grady's murder of his family by killing Wendy and Danny—and then, like Grady, presumably himself—so that the hotel can absorb all three of them into its eternal memory system. They will then become permanent additions to its temporal sinkholes, where they can come play with all the other ghosts in their eternal revelries.

Redrum
(1:57:49 – 2:05:36)

The next shot illuminates Hallorann's snowcat making its way slowly up the side of the mountain toward the hotel. From inside the cab, Hallorann is peering out through the snow drift, windshield wipers on full blast as his headlights press back against the almighty darkness of the ancient wintry night.

Inside the family apartment, meanwhile, Wendy is asleep on the bed while Danny begins chanting the word "Redrum" in Tony's voice over and over as he picks up the knife that his mother had grabbed from the cutlery in the kitchen. Then he crosses the room to the nightstand and takes a tube of his mother's lipstick and uses it to write the word "Redrum" on the yellow surface of the closed bathroom door. Then he stands in front of the bed, lipstick tube in one hand, knife in the other chanting "Redrum" louder and louder until his mother wakes up, terrified, and sees the word "Murder" reflected in the mirror on the nightstand across the room.

Kubrick scores this scene using the opening bars of Penderecki's 1971 liturgical piece *Utrenja II: The Resurrection of Christ* (whereas *Utrenja I,* written the year before had

concerned *The Entombment of Christ*).[55] And indeed, the sound of the axe that comes crashing into the apartment's front door indicates that Jack has been liberated from his tomb and, in a manner of speaking, "resurrected."

As Wendy herds Danny into the bathroom—heedless of the fact that Danny-as-Tony has already indicated that a "murder" will take place there—Jack continues hacking through the front door with an axe, and when the wood paneling is cleared sufficiently away, he reaches in and unlocks the door. "Wendy," he says, "I'm home," which is actually another way of saying that he has been resurrected. His stay in the dry goods larder is morphologically comparable to the entombment of Christ, and when Grady unlatched the bolt to its door, it is as though the stone had been rolled away from the tomb.

Traditionally, the curved blade of the axe was equated with the crescent moon—as in the double axe motif from Minoan Crete which suggested both the waxing and then the waning of the moon.[56] The moon, furthermore, is dark for two days on the New Moon cycle, and then a sliver of light begins to appear on the third day, which is why Christ is crucified on Holy Friday, descends into Hell on Saturday and is resurrected on Sunday. He has appropriated *both* the lunar and the solar powers, but in Jack's case, he is the dying and reviving lunar god only. There are no solar powers attributed to him except insofar as he has gone down into the underworld during the winter solstice, where his personality has been occluded and taken over by the other entity which I am calling "Not-Jack."

Inside the bathroom, meanwhile, Wendy manages to push up the window just enough to allow Danny to slide out through it down the huge snowhill that has covered one side of the hotel. He waits anxiously at the bottom for his

mother to follow, but the opening is too narrow and she tells him to run and hide. Then she cowers in the corner near the doorway to the bathroom, knife in hand as her only defense.

Jack taps on the door and when there is no response says, "Little pigs, little pigs, let me in." Then he continues to mimic the nursery rhyme of The Three Little Pigs by saying that he will then proceed to blow their house in. He begins hacking into the wood of the bathroom door that has already been marked with the backwards word "Redrum," while Wendy screams for mercy on the other side.

Heedless of her screams and bent, this time, on not disappointing Grady or the Overlook Hotel, he chops through one of the rectangular wood panels, then leans in close to the door and says, "Heeeere's Johnny!" This is perhaps the film's most famous and iconic moment, for Jack in this one shot resembles a Native American shamanic mask more than at any other point in the film. As he reaches down to unlock the door, Wendy slices into his knuckles with the carving knife, just as before, in their encounter on the stairs of the Colorado Lounge, she had hit the knuckles of his other hand with the baseball bat.

Meanwhile, outside the hotel, it is nighttime and the exterior floodlights show the arrival of Hallorann's snowcat, with its two headlights piercing the gloom.

Back inside the apartment, Jack stops for a moment, having already hacked his way through the *second* paneling (another double motif) when he hears the snowcat's engine pull up out front. Inside the bathroom, a terrified Wendy hears it too, wondering who it could be who has come to save her and Danny from this creature that is bent on destroying them.

Jack pauses a moment, glancing back at the bathroom, as

he decides which prey would be more to his advantage. He decides on getting rid of Hallorann first, since Hallorann's arrival would interrupt the murders and there would be a chance that he would not be able to complete them yet again.

Hallorann's Arrival
(2:05:37 – 2:08:58)

Danny is now shown running down the hallway of the Overlook near the kitchen. He spots one of its stainless steel cabinets, slides open the door and crawls in and hides, sliding the door shut behind him as he cowers in terror.

Wendy, still breathing heavily from being nearly chopped into pieces, is inside the bathroom and decides to leave it, but has trouble—once again, for everything occurs in repetitions in *The Shining*—with the lock, just as she had had trouble with the lock to the dry goods larder when she had been using it as a temporary prison for Jack.

Jack, meanwhile, is shown limping his way through the kitchen carrying his axe, bent over nearly double with all his injuries. He is scarcely human anymore, and no traces remain of his former personality. The hotel is acting through him now, and it is most especially alarmed by the arrival of Hallorann, an outside party that could prevent the completion of another one of its circular returns.

Hallorann is then shown approaching the hotel lobby's double doors from the outside. He shoves one open against the snow and enters the dimly lit hotel, yelling "Hello?

Anybody here?" as his voice carries through its empty corridors, acting like a sonic tracer to reveal where his exact presence is located at any given moment.

Jack pauses at the entrance to the reception area, hearing the voice of Hallorann, then decides to hide himself behind one of the lobby's pillars.

Hallorann, meanwhile, heedless of the danger, is still shouting as he walks along the main lobby entrance area. He has already taken a right, and when he reaches the last pillar on the right—the one that is immediately located just past the model of the hedge maze (for Jack has now become the monster *in* the labyrinth)—Jack jumps out and swings the axe directly into Hallorann's chest with a woodcutter's blow that sends blood spraying from Hallorann's heart. He collapses instantly, felled like a mighty tree in the forest.

Danny has screamed simultaneously with Hallorann's murder, and now Not-Jack rises up slowly into the frame, grinning to himself because Danny has inadvertently revealed his location to him. Kubrick once again scores this sequence to the opening of Penderecki's dramatic *Utrenja II: The Resurrection of Christ*, and its chorus of voices now begin to function as the awakening of the hotel's dead.

Blood has been spilled in the hotel for the first time all winter, and Hallorann's blood—leaking directly from his heart—has given strength to the hotel as it greedily drinks it in, making it stronger than ever. From henceforth, ghosts and spooks now begin to leap out from every nook and cranny, energized by the spilling of Hallorann's blood. It is, indeed, the "resurrection" of the hotel, which, with the spilling of human blood, has now come fully to life.[57]

The vector traced out by Hallorann from Miami to the Overlook has been one that could've prevented the circle of Eternal Return from recurring and closing in on itself once

more with Jack's re-performance of Grady's murders. That was the one thing which the Overlook as an organism feared, since it would've deprived it of the much needed human lifeblood upon which it thrives. But now that it has drunk Hallorann's blood, its powers have suddenly awakened to full speed and it wears Jack like a mask in order to finish the re-performance of the Grady killings that will close the circle of Uroboros for it once more.

Navigating the Labyrinths Part I
(2:08:59 – 2:12:11)

Jack, having heard Danny's scream, limps over to the hallway leading to the kitchen and yells his son's name. The proximity of his homicidal father terrifies Danny into revealing his presence as he slides open the pantry storage door and runs out. He has the advantage of speed over his father, who is wounded with a sprained ankle and must hop with a limp after him.

Wendy, meanwhile, is making her way through the labyrinth of the hotel looking for Danny. For some reason, she thinks he has gone upstairs and a shot now follows of her ascending a spooky staircase, yelling Danny's name. Then, for the first time in the entire film, Wendy herself sees a supernatural apparition in one of the rooms, a bizarre image of a person in a bear suit performing what looks like fellatio on a man lying on a bed who sits up when he sees her. Sex acts between humans and animals are a common motif of Native American mythology, but the semiotics of the scene are not clear. What is clear, however, is that only Jack and Danny thus far have witnessed supernatural events and interacted with the ghosts of the hotel. Wendy has never seen anything supernatural until this point, and that is most likely because the hotel has been powerfully energized by the

spilling of Hallorann's blood, so that its memory fields are activated all around the hotel, there for anyone to witness, including those who, like Wendy, it has no particular interest in absorbing into its memory reservoirs. Wendy, knife in hand, screams at the apparition, then flees down one the hallway, still searching for Danny.

Meanwhile, Jack has followed Danny to the open lobby doors of the hotel's front reception area. He yells after him and looks out into the gloom, but all he sees is Hallorann's snowcat (behind which Danny is hiding). He thinks perhaps Danny has vanished into the hedge maze, so he turns on the breaker switches to all the maze's night lights, then proceeds across the snow just as he catches sight of Danny actually running into the maze.

Kubrick's Steadicam then follows Danny into the labyrinth, like Theseus going in to slay the Minotaur, only the traces of his footsteps in the snow will serve in place of the ball of string that Ariadne has given him to find his way back out again.

Unbeknownst to his father, Danny is laying a trap for him, since he and his mother have already navigated the hedge maze at least once, whereas Jack has never been shown walking through it. Danny knows the lay-out of the maze, but his father does not.

Also note that leading Jack out of the hotel—where everything occurs in circles—has had the effect of breaking his circular, repetitious motions and tracing a new line of flight that leads in rectilinear fashion through a complex maze, but not a circular one. Danny has already begun the process of shifting the mythic circle of the serpent biting its tail to the older geometric motif of the labyrinth that has only *one* solution: one traces a line in, and then a line out. Repetition does not occur. The labyrinth must be solved, not

cycled like the eternal returns of the planets.

Jean Gebser, in his essay on "Cave and Labyrinth" reminds us that, whereas the dark and unlit cave is symbolic of a regression of consciousness to the timeless and directionless primordial magical structure—think of Jack asleep inside the dry goods storage larder--the labyrinth is already half-lit and beginning to find a way *out* of the darkness and toward the light. Gebser says that the Ariadne thread that Theseus clings to in the myth in order to find his way out of the labyrinth after he kills the Minotaur is actually the thread of waking consciousness by means of which he finds his way back out of the maze and into the light of day.[58] In *The Shining*, the fact that Danny *leaves* his father trapped behind in the labyrinth—for his father has already regressed back into the uteromorphic magical consciousness structure that the hotel has enclosed him within—and finds his way back out again by retracing the Ariadne thread of his own footprints is an indication that he is coming *out* of the darkness of unconsciousness and into the light of waking day. Danny has a future (and as the archetypal Wonder Child, like the Christ child sitting on the Madonna's lap, he *is* the future), but his Minotaurish father does not.

The hotel is itself a labyrinth, too—one that Wendy is simultaneously trying to find her way out of, while her son is busy leading his father into one in order to trap him there—but it is a labyrinth built out of temporal circles and repeating time loops. The spatial lay-out, with its multiple floors and rooms is labyrinthine, but its temporal lay-out, as we have seen demonstrated time and time again throughout the film, is that of repetition rather than difference.

Navigating the Labyrinths Part II
(2:12:12 – 2:19:29)

Wendy is presently shown, knife in hand, navigating her way through a kitchen hallway strewn with a mess made by one of Jack's earlier tantrums when he had flung tiny circular stainless steel utensils all over the floor. (It is fitting that these are miniature circles). She rounds another corner to the main lobby, and Penderecki's *Utrenja II* then resounds at the precise moment when she sees Hallorann's dead body lying on the floor in a pool of blood. Things are looking more and more bleak for her and Danny. The help that had arrived to save them has been intercepted by the supernatural forces of the hotel using Jack as their puppet.

As Wendy uncertainly steps forward, she senses another presence behind her and turns to see a man dressed in a tuxedo raising a drink as though for a toast who tells her, "Great party, isn't it?" The man's head has been split open with a seam that runs from the crown of his skull to the bottom of his jaw. He is one of the hotel's revelers at its eternal *Walpurgisnacht*.

Outside, in the frosty blue lighting of the hedge maze, Danny is still running well ahead of his father, who limps after him telling him that he can't get away as he follows his son's footprints in the snow.

Back inside the labyrinth of the hotel, Wendy approaches the lobby (apparently from the other side, for she seems to have taken a corridor leading around it) and stumbles upon another one of its temporal sinkholes: this time, the lobby is full of cobwebs and dim blue light, as though it were light cast by the moon, and the chairs are populated with skeletons still wearing clothing from the 1920s. The tables in front of the skeletons have champagne bottles and glasses laid out, as though they had suddenly died in the midst of some party. And there are even skeletons standing in the phone booths lined up against the lobby's north wall. A man serving drinks on a tray is frozen in time, where he stands before a group of revelers seated in four of the lobby's chairs around a table strewn about with noisemakers and champagne bottles. Cobwebs have cocooned them all like mummies. It is a temporal sinkhole into which Wendy has stumbled, one of its many gravitational wells that pull the unwary over its event horizon to become trapped inside one of the resonant echoes of its many memories of parties long gone.

Inside the hedge maze, meanwhile, Danny is now retracing his footprints in the snow, walking backwards for several paces until he is satisfied that he has gone past the point where his father will stop. He jumps away from his footprints and erases his movements in the snow as he crawls away to escape down another corridor.

If Jack will wind up trapped inside an architectural construction of *space*, his wife Wendy, still trapped inside the maze of the Overlook Hotel, remains stuck in one after another of its *temporal* sinkholes. It is a maze built out of temporal corridors and old, worn-out memories that are engrained in the hotel's collective consciousness.

Presently, she rounds yet another corner to be confronted with the very same vision of the tide of blood which Danny had witnessed in the bathroom while he was talking to Tony in the mirror in Boulder before they had left for the hotel. The blood of all the dead who have died over the many decades of the hotel's existence begins to wash across the walls and floors, while Wendy, terrified, watches in disbelief.

Danny, meanwhile, is shown hiding on the other side of a snow-encrusted hedge wall past which his father limps, axe in hand, still yelling after his son. Jack stops and pauses for a moment, realizing that he has been outsmarted, and then proceeds down the *wrong* corridor, while Danny appears from his hiding place and begins to make his way out of the labyrinth by retracing the Ariadne thread of his own footprints.

Jack, meanwhile, is lost, confused and disoriented—just as he has become lost inside the cavern of his own mind—and the subzero temperatures are beginning to catch up to him.

Danny escapes from the spatial labyrinth of the hedge maze just as his mother has escaped from the temporal labyrinth of the Overlook Hotel. Both are reunited and hug each other. (Thus, the Madonna and child iconotype which evolved during Byzantine times from the Isis and Horus cults, points to the dawn and the future evolution of consciousness from out of the dark abysses of an endless night).[59]

On the inside of the labyrinth, Jack is slowly freezing to death. He hears the engine of the snowcat start up as mother and son finally escape from the hotel and drive off into the wintry darkness.

It appears, then, that the line of flight traced out by Hallorann *has* actually cut the circle of Eternal Return, only

not in the way he had hoped. If he had not made the journey to the hotel and left the mother and child with a functioning snowcat, then they would've been trapped and eventually murdered by Jack who would've finally completed the circle of Eternal Return.

But mother and son have *broken* the circle and prevented the recurrence of the myth (precisely be reconstellating the Christian mythos of the singularity of the Incarnation of the Christ child whose advent portends an end to all previous circularities of the mythical consciousness structure and is already pointing the way toward the mental consciousness structure with its three-fold temporal organization, not of eternal return, but of past-present-future. All subsequent models of history in the West become based on this schema, from Joachim of Floris's three ages of the Father, Son and Holy Ghost [that is, the Age of the Chosen People, the Age of the universal church, and the Age of the Benedictine monk] down to the academic Ancient-Medieval-Modern schemas that reigned until Oswald Spengler, with his 1918 magnum opus *The Decline of the West*, dismantled them, even while Heidegger, who had read Spengler, continued to perpetuate the model with his pre-metaphysical, metaphysical and post-metaphysical stages of the West's understanding of being. That is to say, Being understood as *physis* for the pre-Socratics and then from Plato to Husserl, Being is understood as a divorce that occurs between Transcendence and Becoming, while the post-metaphysical understanding which Heidegger, in his later works, believed he was inaugurating as the Time of the Between, features Being as Evental [i.e. Being-as-*Ereignis*].[60] Danny's escape from the abyss of the endless *Walpurgisnacht* and from the labyrinth which corresponds to it suggests the possibility, like the descent of the embryo in the last frames of Kubrick's *2001: A Space Odyssey*, of a Rupture with *all* the

abysses of the past and the possibility of a new *Ereignis* event. Thus, the birth of the Christ child at the moment of the winter solstice is a hidden mythic structure that functions like a stencil organizing the events of Kubrick's climactic final moments of *The Shining*).

Jack inside the labyrinth, meanwhile, represents the stiffening and rigidifying models of the past and all its worn-out modes of magical, mythical *and* mental consciousness structures. Fittingly, he walks around in ever-narrower and narrower circles, spinning about helplessly as he freezes to death.

Frozen in Space; Frozen in Time
(2:19:30 – 2:21:26)

There now follows a daytime shot of Jack completely frozen to death inside the labyrinth. The sound of the wind can be heard whistling about him (ironically, he has suffered the same fate as several members of the Donner Party near Lake Truckee in the harsh winter of 1846-47). He has become trapped, like the Minotaur in Greek myth, as the monster inside the labyrinth who will never be allowed to leave. Jack's body has become a permanent physical addition to the hotel's property. When the snows thaw out in the spring time, his corpse will be found, if not sooner, but he has traced a series of circles that have only led him spiraling down inside of himself to the still point at the center of the circle that acts as the pivot but does not itself turn.

Meanwhile, in an epilogue, Kubrick cuts to an interior shot of the hotel where the camera closes in on a wall of black and white photographs that have been taken at various moments in the hotel's past. The wall of photographs is located directly across the hall from the Gold Room, and the song, "Midnight, the Stars and You," which had been playing earlier in the film when Jack had first entered

the Gold Room during a 1920s party there, is presently playing over the soundtrack once more. There are exactly 21 photographs on this wall, and the camera zooms in to the middle row, middle photograph—and hence the pivot of the entire composition--where it shows an authentic photograph taken at a July 4th party in 1921. Jack Torrance is clearly shown present at the bottom of the picture.

In his interview with Michel Ciment, Kubrick remarked that the photograph was a real one taken in 1921—notice that no one in the picture is holding a drink—and that Jack Nicholson's image was simply added to the composition. In that interview, he also tells Michel Ciment that he intended to suggest that Jack had been reincarnated and returned to the hotel decades later.

Jack has thus been frozen in time as a permanent memory trace of the Overlook's collective consciousness. Hence, when Grady told him that he'd *always* been there, that is what he had meant. And when Jack told Wendy early on in the film when she had served him breakfast in bed that during the interview with Ullman he'd had a creepy sense of déjà-vu, as though he'd been there before and knew what was going to be around every corner, Kubrick was specifically referring to this notion of Jack's having been reincarnated and returned to the hotel many decades later (an idea that is absent from King's novel). The idea reiterates, however, the notion that everything inside the Overlook Hotel recurs in circles. No new events ever transpire, only old ones that re-occur.

Jack was meant to return to the same hotel he'd been at before and also to re-perform Grady's murder of his family, so that Jack *together* with his family this time could be absorbed into the Overlook's memory system as residual entities trapped there for eternity, to come and play with its ghosts and their eternal games.

As the credits come on, the song (once again) goes: "I know all my whole life through / I'll be remembering you."

Thus, though Jack Torrance has failed to perform the hotel's wishes in murdering his family—since Hallorann's vector of arrival cut that particular circularity—nonetheless he has been absorbed, once again, into the hotel's consciousness as its eternal caretaker. He is stuck, petrified for all time, inside the myth of the Eternal Return. Whereas his son has traced a line of flight down the Magic Mountain and its eternal revelries into the (unknown) possibilites of the future.

The implication is that future winter caretakers will be having conversations with *Jack's* ghost instead of Grady's, for Kubrick leaves us feeling quite certain that the Overlook Hotel is still hungry for human blood.

Endnotes

A Few Words Before the Play: On Difference & Repetition in *The Shining*

1. Gilles Deleuze, *The Logic of Sense* (NY: Columbia University Press, 1990), 12 ff.
2. See Vilem Flusser, *Writings* (University of Minnesota Press, 2002), 42ff.
3. See Eric Havelock, *Preface to Plato* (Boston, MA: Belknap Press, 1963).
4. See "Chapter II Repetition for Itself" in Gilles Deleuze, *Difference & Repetition* (NY: Columbia University Press, 1994), 70ff.
5. Alain Badiou, *Being and Event* (London & NY: Continuum, 2006).
6. See Badiou's more accessible presentation of his ideas for the general reader in *Ethics: An Essay on the Understanding of Evil* (London & NY: Verso Books, 2001), 68.

Opening Credits: The Ascent up the Mountain

7. The mountain lake, high up in the Rockies, may also be an oblique reference to Lake Truckee in the Sierras, where the Donner Party were snowbound for four months during the winter of 1846-47. See the chapter entitled "Ascent

Redux" for more on the significance of the Donner party to the narrative.

8. See the chapter "The Salt of Soul, the Sulfur of Spirit" in James Hillman, *A Blue Fire* (NY: Harper & Row, 1989) 112ff.

9. Including the fact that The Stanley Hotel's founder (the hotel King stayed at in Colorado) Freelan Oscar Stanley had the hotel built in 1909—Kubrick gives the same date for the completion of The Overlook Hotel—as a place for tubercular patients. He himself was cured of tuberculosis after staying there for a time. He died in 1940. Interestingly, he also had a twin brother, Francis Edgar Stanley, with whom he built the famous Stanley Steamer automobiles from 1902-1924.

10. In an interview with Michel Ciment, however, Kubrick states that the opening score was based on the traditional *Dies Irae* (i.e. "Day of Wrath"). However, when one listens to various versions of the *Dies Irae*, as in the case, for instance of Mozart's *Requiem*, or the *Dies Irae* from Verdi's famous *Requiem*, or even another *Dies Irae* done by Berlioz for his *Grande Messe des Morts*, *none* of them sound remotely like Berlioz's adaptation of the *Dies Irae* that he did for his *Symphonie Fantastique*, which is unmistakably the one that Kubrick has adapted for the opening score of *The Shining*. See the interview online at: http://www.visual-memory.co.uk/amk/doc/interview.ts.html

11. See "Walpurgis Night" in *Goethe's Collected Works Volume 2: Faust I & II* (Princeton, NJ: Princeton University Press, 1994), 99.

12. *Symphonie Fantastique* can be listened to in its entirety on YouTube at: https://www.youtube.com/watch?v=g2Kky5BC9Uk

13. See synopsis on Wikipedia at: en.wikipedia.org/wiki/

Symphonie_fantastique

14. Gianni Vattimo, *The End of Modernity* (Baltimore, MD: Johns Hopkins University Press, 1988) 176-177.

15. Jean Gebser, *The Ever-Present Origin* (Ohio University Press, 1985).

The Interview

16. See the chapter "587 BC – AD 70: On Several Regimes of Signs," in Gilles Deleuze and Felix Guattari, *A Thousand Plateaus* (University of Minnesota Press, 1987), esp. page 119 where they insist that all sign regimes are mixed.

17. It is, furthermore, reputedly haunted in real life.

18. See his description of the book's conception online at:http://stephenking.com/library/novel/shining_the_inspiration.html

19. See the chapter "The Mission" in John David Ebert, *Apocalypse Now Scene-by-Scene* (Eugene, OR: Post Egoism Media, 2015), 37.

20. See the essay entitled "The Future of Writing," in Vilem Flusser, *Writings*, ibid., 63-64.

21. James Joyce, *Finnegans Wake* (NY: Penguin Books, 1967), 215.

The Episode in Boulder

22. In her biography on Stephen King, Lisa Rogak quotes King to the effect that one of the reasons he wrote The Shining was to exorcise his growing emotions of anger and hostility towards his children that he was feeling, especially while living in Boulder. He says that one day when his son Joe was three, the boy got hold of one of his father's manuscripts and "thought he'd write like Daddy. So he took

his crayons and drew little cartoons all over one of Steve's novels-in-progress. When Steve saw it, he thought 'the little son-of-a-bitch I could kill him.'" See Lisa Rogak, *Haunted Heart: The Life and Times of Stephen King* (New York: St. Martin's Press, 2008), 79.

23. See the chapter entitled "The Soul's Death Pole" in Jean Gebser, *The Ever-Present Origin*, ibid., 205ff.

24. See Stuart Schiff, ed. *Whispers Magazine*, August, 1982.

25. See the chapter, "Sacred Space, Holy Time and the Maya World" in Linda Schele, *A Forest of Kings: The Untold Story of the Ancient Maya* (NY: Quill, William Morrow, 1990), 64ff.

26. See "Sacrifices and Wars of the Aztecs" in Georges Bataille, *The Accursed Share, Volume 1: Consumption* (Boston, MA: Zone Books, 1991), 45ff.

Ascent Redux

27. See the PBS documentary, *American Experience: The Donner Party* which can be found online at: https://www.youtube.com/watch?v=_whUMrV9Me8

The First Sighting

28. *Lontano* can be listened to on YouTube at: https://www.youtube.com/watch?v=l2OQbA3r78M

The Tour

29. See the essay by John Layard, "The Malekulan Journey of the Dead," esp. the subsection entitled "The Labyrinth Motive in the Journey of the Dead: Sand Tracings in Southwest Bay," in Joseph Campbell, ed. *Spiritual*

Disciplines (Princeton University Press, 1985), 137ff.

30. See, once again, Deleuze and Guattari for their discussion of sign regimes and how they are overcoded and undermined by older cultures in their chapter "On Several Different Regimes of Signs," in *A Thousand Plateaus*, ibid., esp. pp. 137-138.

The Conversation

31. See Jean Gebser, *The Ever-Present Origin*, ibid. 56-59 for illustrations of this mouthless motif.
32. See John H. Taylor, *Death and the Afterlife in Ancient Egypt* (The University of Chicago Press, 2001), esp. 190 for this ritual, although the image on the book's cover shows the ritual in progress.
33. See the interview with Michel Ciment which can be found online at: http://www.visual-memory.co.uk/amk/doc/interview.ts.html
34. The story is recounted in N.K. Sandars, *Poems of Heaven and Hell from Ancient Mesopotamia* (NY: Penguin Classics, 1971), 117ff.

Waking Up

35. See, for examples, Claude Levi-Strauss, *The Way of the Masks* (University of Washington Press, 1988).

The Hedge Maze

36. Bartok's piece can be listened to on YouTube at: https://www.youtube.com/watch?v=rFsvgYmSDeM
37. See the interesting discussion on building a miniature duplicate of Kubrick's hedge maze by Adam Savage in the

YouTube video entitled "Adam Savage's Overlook Hotel Maze Model," which can be found online at: https://www.youtube.com/watch?v=zAGu2TPt_78

The Interruption

38. See the video entitled *Staircases to Nowhwere: Making Stanley Kubrick's The Shining*, with Jan Harlan's interesting comments on his second unit shots of the Timberline Lodge which occur at about 1:54 into the documentary, which can be found on Vimeo at: //vimeo.com/66584974

Ruptured Lines

39. See Paul Virilio, *Negative Horizon: An Essay in Dromoscopy* (London & NY: Continuum Books, 2008), 37ff.
40. *De Natura Sonoris No. 1* can be listened to on YouTube at: https://www.youtube.com/watch?v=w38Io51YesQ

Father and Son

41. Johann Gottlieb Fichte, *The Science of Knowledge* (Cambridge University Press, 1982), 94ff.

Jack's First Conversation with Lloyd

42. *The Dream of Jacob* may be heard on YouTube at: https://www.youtube.com/watch?v=wqnAP8yL2ew
43. *De Natura Sonoris No. 2* may be heard on YouTube at: https://www.youtube.com/watch?v=gD73U4x9Tgw
44. For Derrida's concept of the undecidable, see the

essay "Plato's Pharmacy," in Jacques Derrida, *Disseminations* (The University of Chicago Press, 1981), 61ff.

Room 237

45. See Gebser's discussion of the Muses in connection with flowing water and the Soul's Life Pole in Jean Gebser, *The Ever-Present Origin*, ibid., 215ff.

Jack's Report

46. The lyrics to the entire song may be found online at http://maxiocio.net/lyrics/lyrics/Masquerade-Jack-Hylton-sxGoFZWk.html

47. For an extended discussion of the symbolism of the Greek festival of the dead known as the Anthesteria, consult "Chapter II The Anthesteria. The Ritual of Ghosts and Sprites" in Jane Ellen Harrison, *Prolegomena to the Study of Greek Religion* (Princeton University Press, 1991), 32ff.

48. However, there are two problems with the photograph taking place during the same party that Jack Torrance has stumbled into. The first is that by 1920, Prohibition had begun, and the Hotel would not (legally, anyway) have been allowed to serve alcoholic beverages in 1921. In fact, it would not have been allowed to serve such beverages until 1934, although alcohol is clearly being served at the party (though it is not present in the photograph from 1921). The second anachronism is that the song "Midnight, the Stars and You" which plays at the end of the film while Kubrick focuses in on the 1921 photograph, was a song that was not composed until 1934, when it was sung by Al Bowlly for Ray Noble's band. In an interview with Michel Ciment, Kubrick mistakenly tells Ciment that the song was a popular dance

tune from the 1920s, and it certainly *sounds* like a 1920s tune. But despite these anachronisms, the fact that the song is heard by Jack Torrance playing in the hotel lobby—and everyone in the Gold Ball Room is wearing 1920s-style fashions—I believe he is deliberately linking this party to the one in the 1921 photograph.

Charles Delbert Grady

49. For the lyrics to "Midnight, the Stars & You" consult the following site: http://lyrics.wikia.com/Al_Bowlly:Midnight,_The_Stars,_And_You

Hallorann on His Way

50. See "The Mental Structure" in Jean Gebser, *The Ever-Present Origin*, ibid., 73ff.

51. For the concept of *Ereignis* as a singular event that inaugurates a whole new understanding of Being, see Martin Heidegger, *Contributions to Philosophy (of the Event)* (Indiana University Press, 2012), 20-25.

Confrontation

52. *Polymorphia* can be listened to in its entirety on YouTube at: https://www.youtube.com/watch?v=9mYFKJBgxbM

53. See the short story by Thomas Pynchon entitled "Mortality and Mercy in Vienna," a story that was *not* included in his collection *Slow Learner*, and which tells the tale of a Native American man who shows up at a cocktail party in New York and who believes he is possessed by a Wendigo. At the end of the story, he goes on a shooting spree and kills everyone at the party. The story may be found

online in its entirety at: http://www.pynchon.pomona.edu/uncollected/vienna.html

Trapped

54. See the interview with Michel Ciment (and Kubrick's answer to his second question) online at: http://www.visual-memory.co.uk/amk/doc/interview.ts.html

Redrum

55. *Utrenja II: The Resurrection of Christ* may be heard online at: https://www.youtube.com/watch?v=zMLxF93u5Yw

56. Karl Kerenyi remarks on the connection between the axe and the moon: "In the hand of Prometheus, the sacrificer, the ax is meaningful; and it has meaning also in the new-moon situation with which the great festivals of the goddess in Athens were connected." See Karl Kerenyi, *Prometheus: Archetypal Image of Human Existence*, (Princeton University Press, 1991), 59.

Hallorann's Arrival

57. On the connection of blood being drunk by evil spirits, see Mircea Eliade, *Shamanism: Archaic Techniques of Ecstacy* (Princeton University Press, 1972), 43ff.

Navigating the Labyrinths, Part I

58. See Jean Gebser, "Cave and Labyrinth" in *Integrative Explorations: Journal of Culture and Consciousness,* January, 1997, Volume 4, Number 1. This journal can also be found online by searching "Integrative Explorations."

Navigating the Labyrinths, Part II

59. As Hans Belting remarks: ""Some of the temples of Isis that had been closed at the end of the fourth century (as late as 560 in the case of the temple at Philae) were reconsecrated as churches of the Virgin." See Hans Belting, *Likeness and Presence: A History of the Image Before the Era of Art* (The University of Chicago Press, 1994), 33-34.

60. See Martin Heidegger, *Introduction to Metaphysics* (New Haven & London: Yale University Press, 2000).

Bibliography

Badiou, Alain. *Being and Event*. London & NY: Continuum, 2006.

___. *Ethics: An Essay on the Understanding of Evil*. London & NY: Verso Books, 2001.

Bataille, Georges. *The Accursed Share, Volume 1: Consumption*. Boston, MA: Zone Books, 1991.

Belting, Hans. *Likeness and Presence: A History of the Image Before the Era of Art*. The University of Chicago Press, 1994.

Campbell, Joseph, ed. *Spiritual Disciplines*. Princeton University Press, 1985.

Deleuze, Gilles. *Difference and Repetition*. NY: Columbia University Press, 1994.

___. *The Logic of Sense*. NY: Columbia University Press, 1990.

___. and Felix Guattari. *A Thousand Plateaus*. University of Minnesota Press, 1987.

Derrida, Jacques. *Disseminations*. The University of Chicago Press, 1981.

Ebert, John David. *Apocalypse Now Scene-by-Scene*. Eugene, OR: Post Egoism Media, 2015.

Eliade, Mircea. *Shamanism: Archaic Techniques of Ecstacy*. Princeton University Press, 1972.

Fichte, Johann Gottlieb. *The Science of Knowledge*. Cambridge University Press, 1982.

Flusser, Vilem. *Writings*. University of Minnesota Press, 2002.

Gebser, Jean. "Cave and Labyrinth." *Integrative Explorations: Journal of Culture and Consciousness*. January,

1997; Volume 4, Number 1.

___. *The Ever-Present Origin*. Ohio University Press, 1985.

Goethe, Johann Wolfgang. *Goethe's Collected Works Volume 2: Faust I & II*. Princeton, NJ: Princeton University Press, 1994.

Harrison, Jane Ellen. *Prolegomena to the Study of Greek Religion*. Princeton University Press, 1991.

Havelock, Eric. *Preface to Plato*. Boston, MA: Belknap Press, 1963.

Heidegger, Martin. *Contributions to Philosophy (of the Event)*. Indiana University Press, 2012.

___. *Introduction to Metaphysics*. New Haven & London: Yale University Press, 2000.

Hillman, James. *A Blue Fire*. NY: Harper & Row, 1989.

Kerenyi, Karl. *Prometheus: Archetypal Image of Human Existence*. Princeton University Press, 1991.

Levi-Strauss, Claude. *The Way of the Masks*. University of Washington Press, 1988.

Rogak, Lisa. *Haunted Heart: The Life and Times of Stephen King*. NY: St. Martin's Press, 2008.

Sandars, N.K. *Poems of Heaven and Hell from Ancient Mesopotamia*. NY: Penguin Classics, 1971.

Schele, Linda. *A Forest of Kings: The Untold Story of the Ancient Maya*. NY: Quill, William Morrow, 1990.

Schiff, Stuart. *Whispers Magazine*. August, 1982.

Taylor, John H. *Death and the Afterlife in Ancient Egypt*. The University of Chicago Press, 2001.

Vattimo, Gianni. *The End of Modernity*. Baltimore, MD: Johns Hopkins University Press, 1988.

Paul Virilio. *Negative Horizon: An Essay in Dromoscopy*. London & NY: Continuum Books, 2008.

www.ingramcontent.com/pod-product-compliance
Lightning Source LLC
Chambersburg PA
CBHW030743180526
45163CB00003B/905